The Beckoning Path

Lessons of a
Lifelong Garden

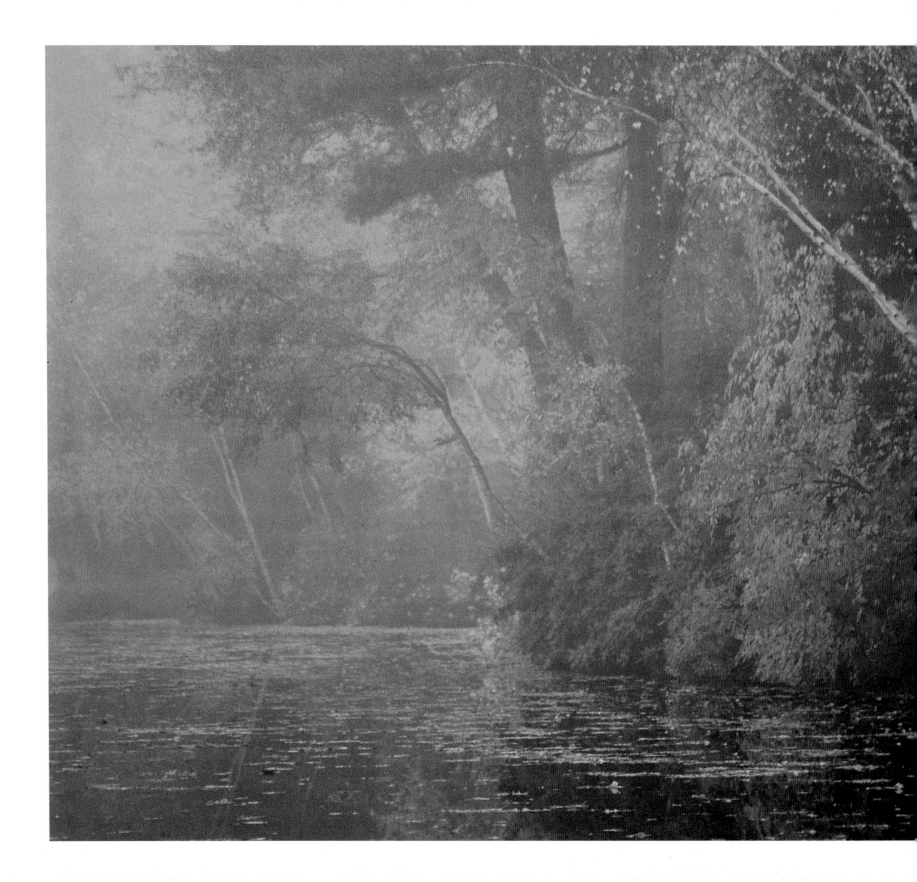

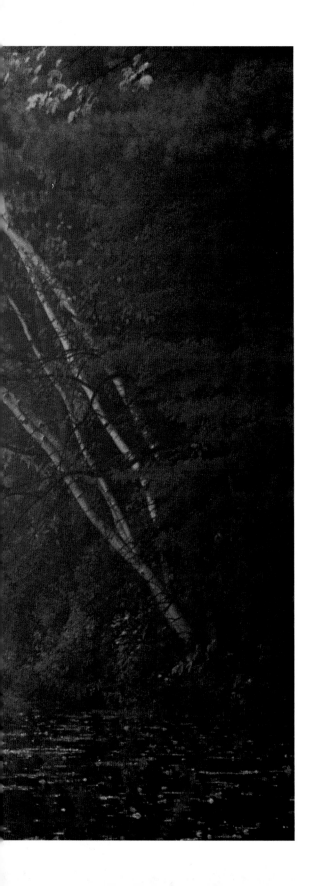

The Beckoning Path
Lessons of a Lifelong Garden

Photographs by Ted Nierenberg

Text by Mark Kane

Aperture

WHEN I FIRST SAW IT, *half a lifetime ago, even in its
overgrown state, this wooded land appealed to my sense of
beauty. Since then, as my family and I settled into the house
perched over the lake, I have dug and moved and pruned
this landscape in every possible moment. Each day, walking
the paths, I see challenges that probably cannot be met this
year, but planning for next year is a joy. A garden's rewards
can be days, months, decades away.*

*From the start, the garden was imagined as a three-
dimensional painting, a metaphor for privacy, intimacy,
seclusion, peace. It would be created by an informed eye,
using a palette of trees and shrubs. The canvas would be the
earth itself, multiplied by the reflective surface of the lake.*

*My vision of the garden and the photographs in this
book are separated by many years. These photographs are
a meditation on all I have learned, working week by week in
rich dirt unearthing the unseen, spidery roots of trees and
shrubs, along with memories of family, ambition,
friendship, and disappointment — the organic elements
of human life. Plants have been moved and removed until
they are perfectly placed and look content, as trees do
after an all-night rain. In the seclusion of this garden,
I have photographed the landscape I love most, in the center
and edges of each season, the dawn and dusk of each
promising day.*—TED NIERENBERG

*RIGHT: When nature is the model and inspiration, the gardener's
touch barely shows. What seems to be unaltered forest is actually
a landscape, planted over thirty-five years on the shore of a lake, where
even the house merges unobtrusively with the illusion of wilderness.*

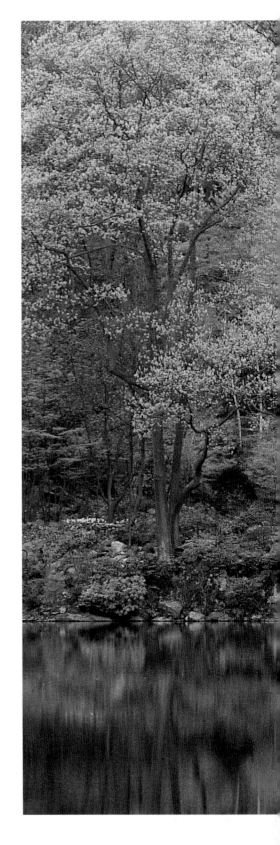

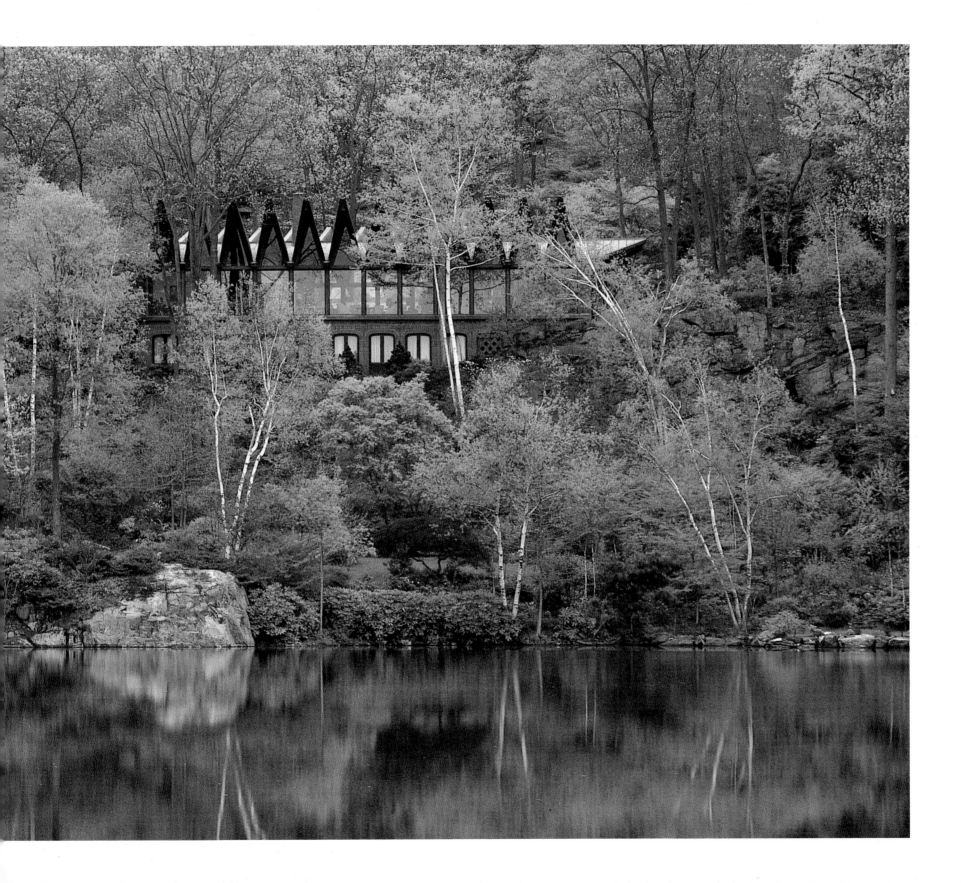

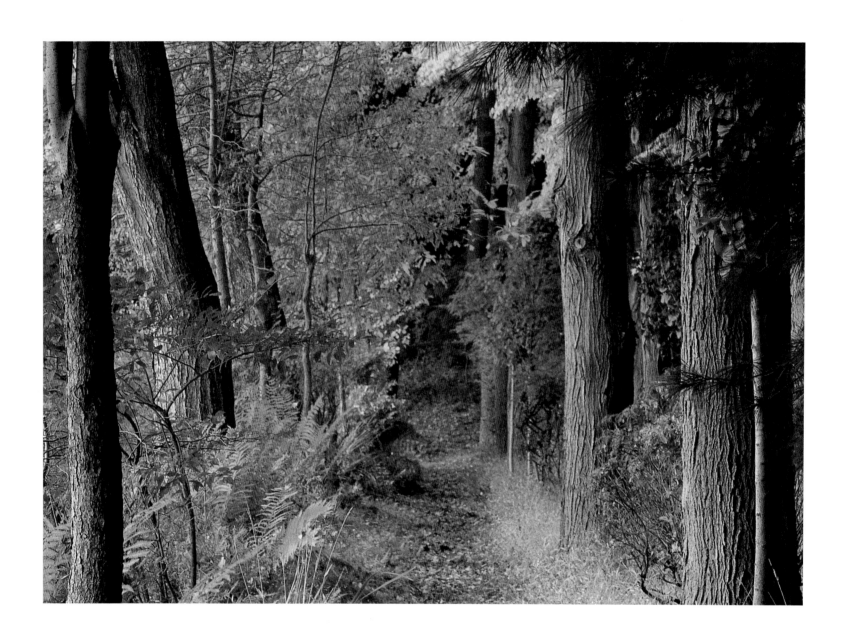

The Beckoning Path
Lessons of a Lifelong Garden
by Mark Kane

A FOREST GARDEN skirts the shore of a lake near Armonk, forty miles north of New York City. Here, ten thousand years ago, a glacier plowed the land and then retreated northward, leaving rugged hills strewn with boulders and bluffs and outcroppings of granite bedrock. Narrow moss-edged paths lead around the lake, and the garden unfolds along them, a succession of perennials, shrubs, and trees planted right to the water's edge against a backdrop of sheltering hills and the native forest of oak, ash, beech, maple, and white pine. If the garden were somehow collected in one spot, it would cover twelve acres and it might be called an estate or a landscape. But the paths offer an intimacy, an arm's-length closeness, that makes the lake and its fourteen-acre long shoreline a garden.

A natural amphitheater, the garden everywhere looks down on the water and across to its own distant reaches. The ancient Chinese garden designers called such sites "saucer gardens." The views are close at hand and underfoot, or up the slopes away from the pond, or across the pond to distant shores, with reflections of the shoreline, the forest, the hills, and the sky.

WALKING THE PATHS, you discover a landscape that is artful enough to seem natural. The seasons are richer, more distinct and various, and a treasury of introduced plants grows thickly below the trees. Redbud from China and Europe bloom beside American natives. Cherry trees from Japan flower in washes of pink while native shadblow trees cover themselves with white blooms. Fall blazes brighter, as Japanese maples turn scarlet and rusty orange, and ginkgos paint themselves gold. The paths that wind along the shore and loop away and back pass under a venerable canopy of trees which have been shaped

OPPOSITE: In Ted Nierenberg's artful garden, the path turns constantly to hide portions of the view. Visitors keep walking to see what lies around the bend, over the hill, behind the grove of trees, hidden in the shady distance.

by more than thirty years of winter prunings.

The man who photographed the garden, Ted Nierenberg, is also the garden's maker. In no particular order, Nierenberg is an enthusiast of art, photography, architecture, design, travel, cuisine, and gardening. He founded Dansk, and led it into the business of making table and housewares of a distinctive Scandinavian design. He learned gardening as a boy on his uncle's farm, where he rooted cuttings and grafted trees; he started a nursery at his first home, a tract house on Long Island. He has visited hundreds of gardens in Japan. He frequents nurseries here and abroad. When Nierenberg first met the writer John McPhee he discovered that he was developing a reputation. "I know you," McPhee said. "At Princeton Nurseries, they say you buy trees like the highway department."

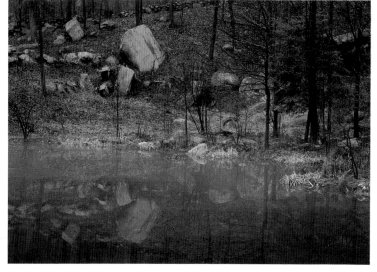

In the early 1950s, when Dansk was still new, Nierenberg and his wife, Martha, set out to build a new house. A painstaking planner, he perused topographic maps in his search for property. Cobamong Lake, near Armonk, caught his eye. The shoreline was irregular, the elevations changed dramatically, and cliffs rimmed the valley: a promising and unusual site for a house and garden.

The property, once a farm, had reverted to a wild state. Long ago, farmers had cleared most of the trees and converted the land to pasture. But the property had lain disused since the turn of the century, when a dam was built that tripled the size and depth of the original lake. (Friends of Nierenberg, diving in the lake, found a submerged stone barn.) By the 1950s, new trees had covered the bare spots between old trees,

ABOVE: The art of gardening includes knowing when nature's handiwork should be preserved. Rather than smooth the contours of the site, Nierenberg has left granite boulders where the glaciers have strewn them.

8

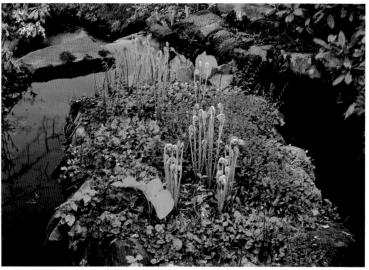

and a tangled understory had grown up.

Nierenberg visited the site and hiked in to look it over. Drawn in by what appeared to be an opening in the formidable tree canopy, he scaled a huge outcropping and gazed down on the lake. He'd found what he wanted. Amid the tangle of grapevines, honeysuckle, poison ivy and sapling trees, he found himself under a canopy of large trees, with a view of a lake sheltered by wooded hills. Later he learned that *Cobamong* was an Algonquin Indian name, meaning "beautiful hidden valley." The name was apt, and became more apt as Nierenberg developed the garden. Today, he calls the property Cobamong.

Nierenberg took stock of the grounds. Yes, there were venerable trees, a grove of white pines, dozens of sugar maples, and the striking white trunks of birches. But there were also brambles, thickets, and the native grapevines climbing into the trees, spreading their leaves high overhead and threatening to overwhelm the forest. Nierenberg began to clear the land judiciously. He spared the best of the native oaks, beeches, dogwoods, hornbeams, mountain laurel, and birches. Slowly, he felled unneeded trees, preserving the canopy for three or four years to let the desirable trees and shrubs get used to more light.

AS CLEARING REVEALED THE SITE, Nierenberg began to see the outlines of the garden to be. Here was the start of an opening in the forest that might provide light for a wildflower meadow. There, the slope offered passage to the side of a boggy stream — a path could cross it, carried by stones. He studied the way water drained during a downpour, where the snow melted first, how the lake froze and where the first ice formed. He and Martha talked

TOP: Nature or art? Accident or garden? An island in a stream sprouts the fiddleheads of young spring ferns, concealing the ring of rocks and the topping of dirt that Nierenberg placed years ago.

about where they liked to sit and why. He noticed which trees had bark he wanted to touch. To escape the tangled undergrowth, he followed the shoreline in a rowboat, routing paths in his mind's eye. He began to compile lists of plants that would suit Cobamong.

As Nierenberg cut the first path around the lake, he asked himself questions. When did he want to walk close to the lake? Above the lake? Which were the important trees and boulders to pass? Should he march the path over the long-untouched needles in the pine grove or leave the place in peace? How should the path cross a brook? What should he grow between the path and the lake? Where should the path become steps, and how should they be made — with rocks or logs?

Then, as now, he recycled everything back to the forest — chipped branches, shredded trimmings of poison ivy, limbs and logs not used for firewood. Once, many years before he purchased Cobamong, Nierenberg had hiked and camped the Great Smoky National Park. He asked a park ranger why the trees grew so strong, lush and healthy and the ranger answered, "Recycling." Every year, the forest returned to the soil a ton of debris per acre, a wealth of nutrients that enriched the earth and sustained the forest.

Nierenberg sited his new house on the outcropping from which he first saw the lake and, as the house took shape, he continued to work on the garden. From his Long Island home nursery, he brought in small shrubs that do well in the shady company of trees — azaleas, mountain laurels, andromeda, leucothoe. Henry Malewitz, an accom-

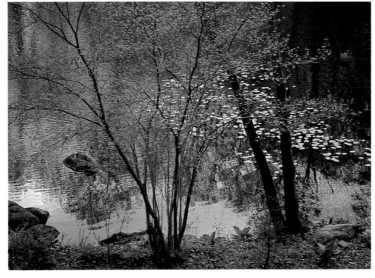

ABOVE: Paths vary the rhythm of a garden. Nierenberg makes them skirt the lake, drawing the eye to the distant shore, then sends the path up a slope, returning the eye to the near shore and the silhouettes of trees against water.

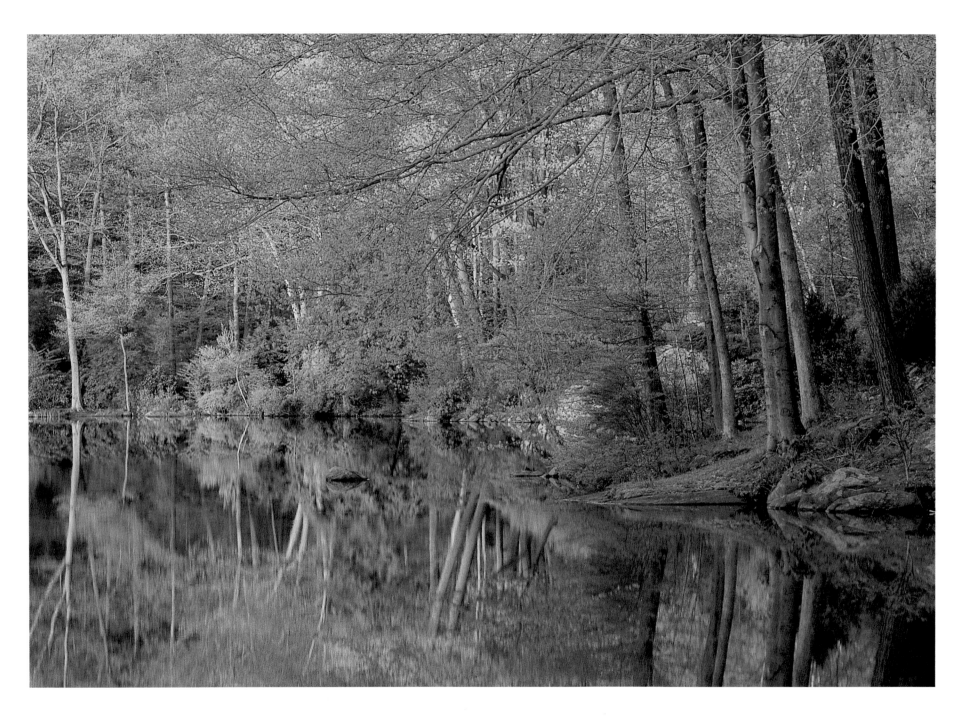

*The garden constantly offers vistas across the water, an invitation
to move ahead into the low sunlight slanting through the trees.*

plished tree man and greens keeper who helped Nierenberg in his nursery, came up from Long Island to inspect Cobamong and fell in love with it. Since then, every Saturday for thirty-six years, Malewitz has commuted one and a half hours each way, arriving before dawn, to work at Cobamong. In the morning before beginning, he walks around the lake, up the steep paths and steps, assessing what is prospering and what needs help. Malewitz could have retired quite a long time ago— he is eighty-three years old — but says working at Cobamong is therapeutic.

In the first few years, Nierenberg traced the outline of the garden. He and Malewitz removed most of the trees below the house, opening the view to the lake. In the clearing, on a nearly level patch of ground near the lake, he laid out an island of turf, the only lawn on the property. Then, from the lawn, which serves as a transition from the house to the forest, he started paths along the shoreline to circle the lake. As he went, vistas beckoned, pulling the paths to vantage points. He found openings for flowers, bulbs, a wild meadow, pleasant places to sit. He began to add shrubs and trees.

Today, the garden is filled in, lush and thriving, but always changing. Nierenberg still continues to plant, to cull, to prune, to move shrubs and trees from their first locations to new sites that better compliment them. Now, having retired, he can be found every day working and photographing in the garden, only taking time away for travel. After thirty-six dedicated years at Cobamong, he continues to follow the beckoning paths he has created.

ABOVE: Along a garden path, details that arrest the eye provide a counterpoint to vistas and longer views, offering a moment for meditative looking.

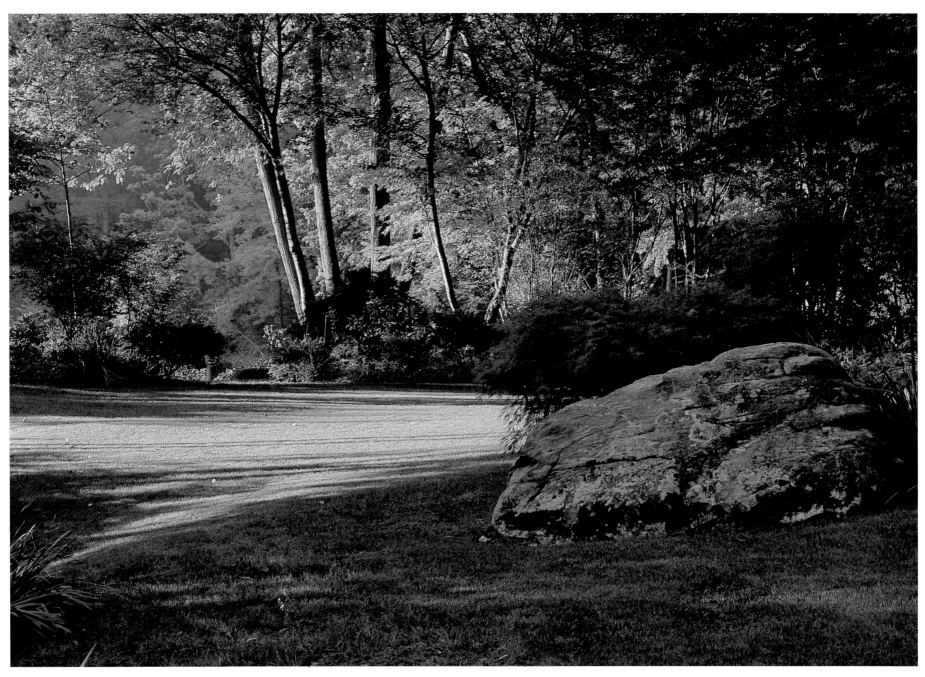

*Gardens need contrasts for variety and drama. In a
woodland garden, wending around the shore of a lake, a clearing
carpeted with lawn offers a return to civilization.*

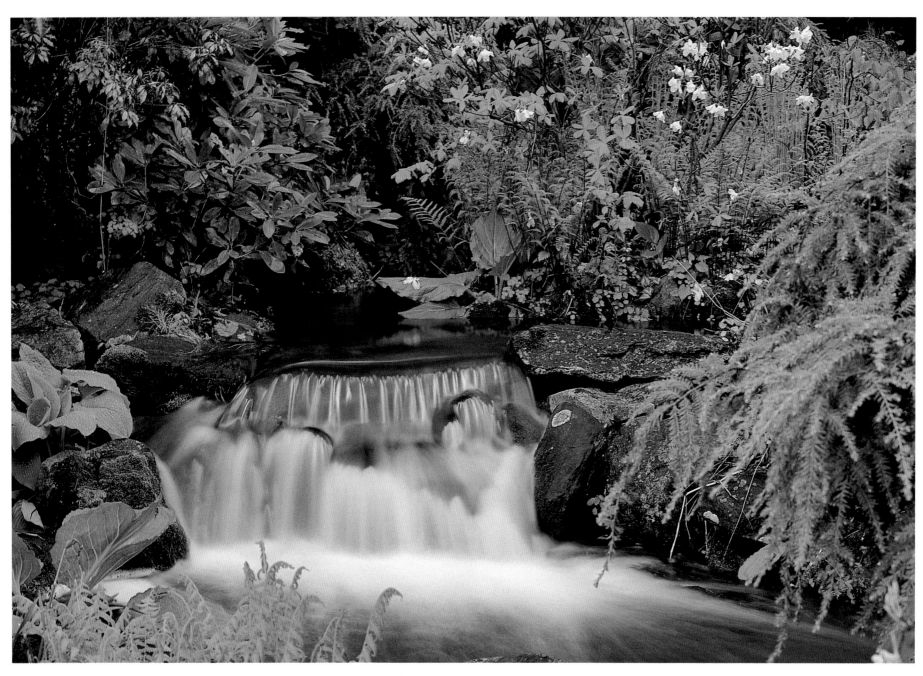

When a visitor turns away from the lake, pulled by the sound of falling water, a rivulet appears spilling over a cascade of rocks. At the top of the cascade, artfully placed, a flat slab makes a small Niagara.

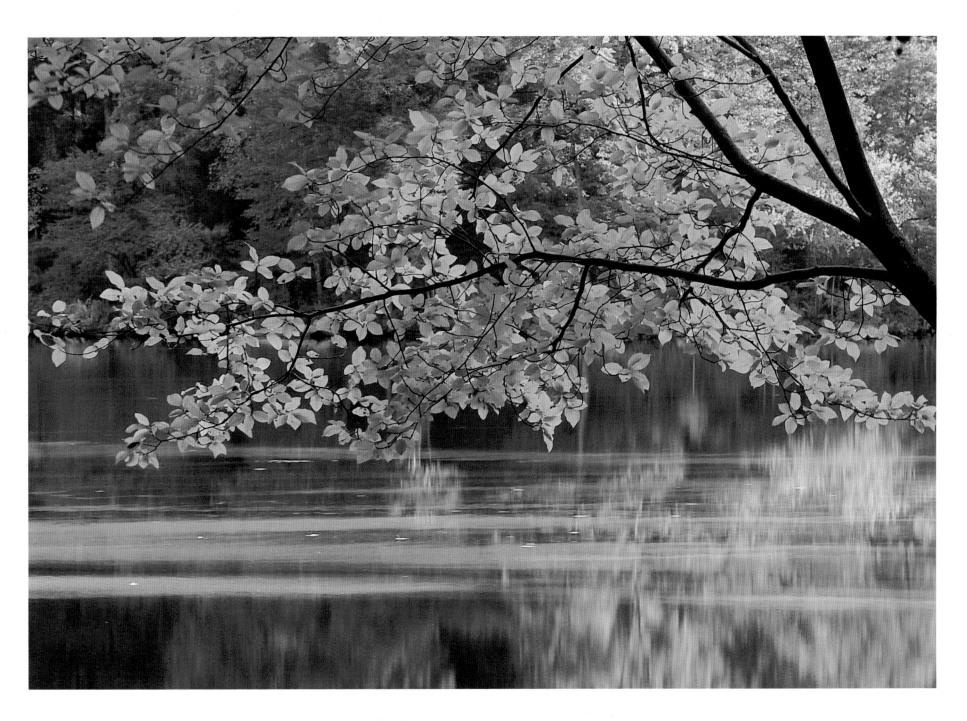

Gardens reveal and hide themselves by turns, in a rhythm that sustains their allure. Low, graceful branches withhold the view for a moment.

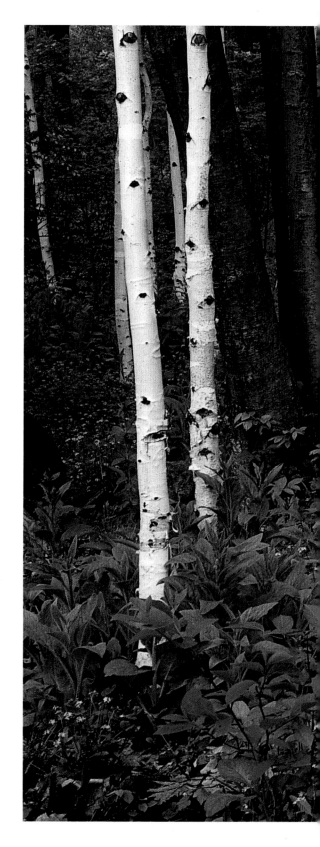

RIGHT: When nature paints with a bold brush, two or three plants dominate the canvas. The same effects, in the hands of a careful observer, can be put to work in the garden. Their white trunks gleaming in the shade, as if randomly spaced, these birches cluster in twos and threes, while a carpet of bluets blooms at their feet. The tableau, though natural-looking, is Nierenberg's handiwork.

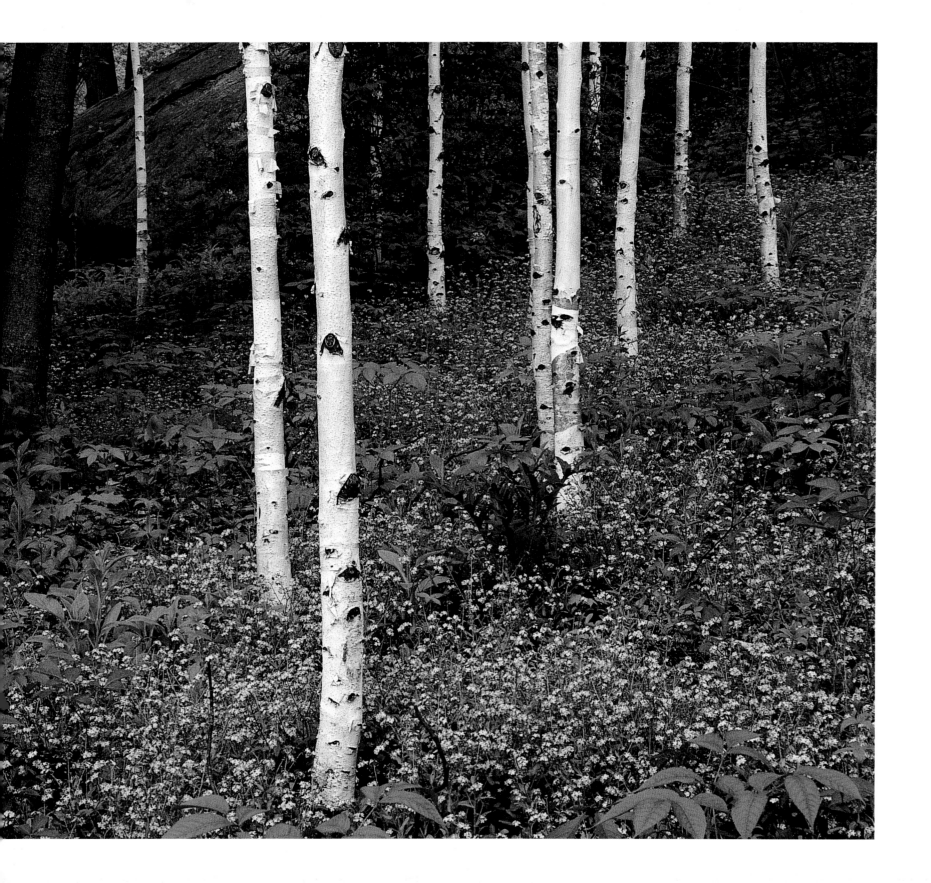

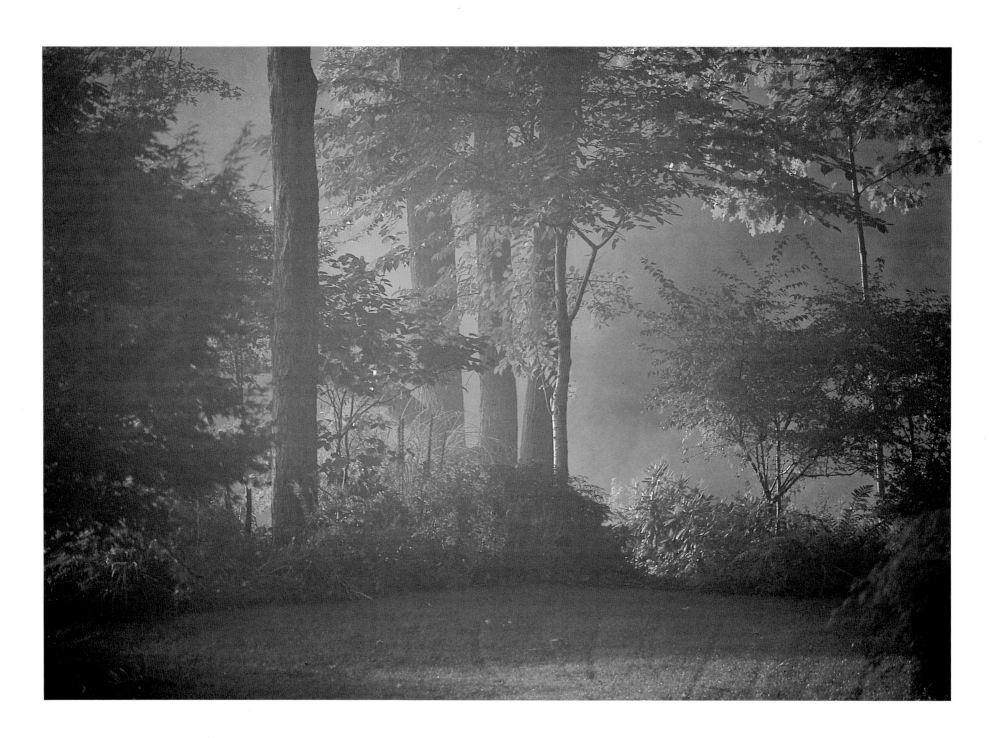

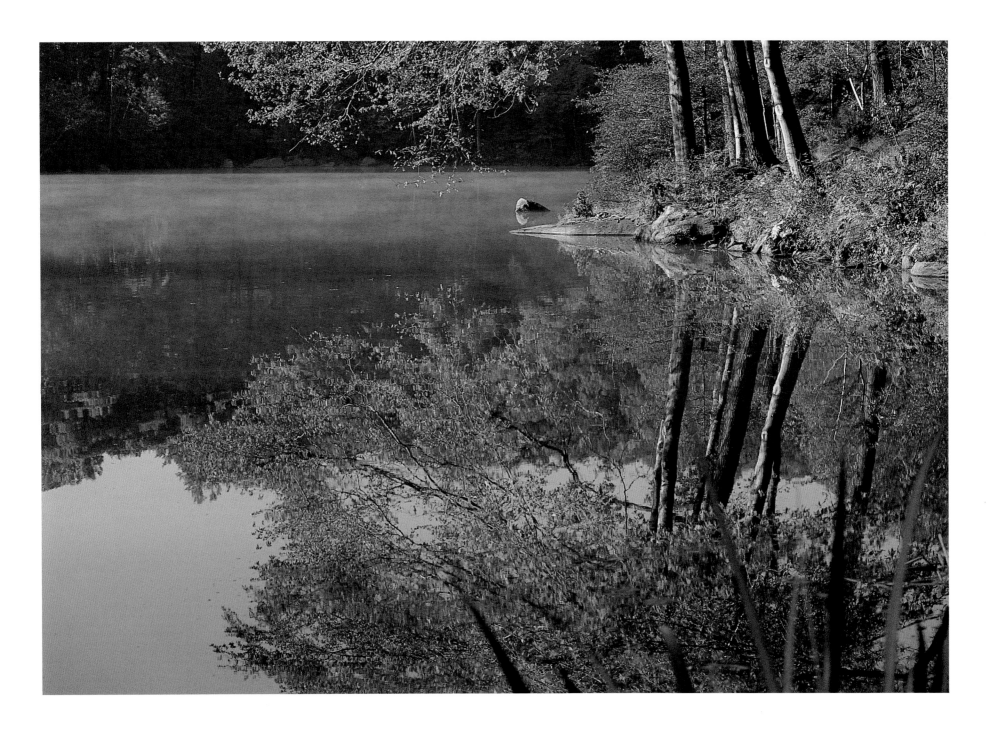

The Genius of the Place

GREAT GARDENS, like great novels, please us deeply because they fulfill our needs for intimacy and art. In a great garden, we come to know the gardener's dreams of Eden, which were born in childhood and are close to the soul. Here we see the temperament of the gardener, revealed by the act of creation. And in a great garden, we revel in the devices of art: mystery, surprise, vignettes, vistas, changing rhythms, nature transformed. They transport and enthrall us, submerging our rational selves in delight.

Great gardens never look alike. I have seen the granite glades of the Sierras imitated on a steep clay hill overlooking the San Francisco Bay; a garden in Seattle where the grass paths flowed like streams between beds of gravel and hand-laid outcroppings dotted with tiny plants from the mountains of the world; a subtropical Texas garden where undulating, sheared azaleas recalled Japanese monasteries; a garden in Connecticut where beds laid out with the order and symmetry of floor tiles overflowed with a romantic profusion of choice and beautiful perennials.

But as different as great gardens look, they are united by the passion of their makers and the subtlety of their art. A visitor who studies Cobamong will come away with secrets that can transform any garden, whether it's a city lot, an acre of prairie in Nebraska, or a canyon side in Los Angeles.

Great gardens suit their time and place. They respect what Alexander Pope called "the genius of the place." The formal garden, with its sheared plants and symmetrical lines and curves, is appropriate to the city and the grand house and society. The informal garden, with unrestrained plants and unpredictable curves, suits the country and the house that is a retreat. Nierenberg knew from the start that

OPPOSITE: When a garden preserves the natural conditions of its region, one glimpse of glacier-smoothed granite, still water and autumn leaves reveals its character.

Cobamong would be an informal garden. Meaning to preserve the genius of the place, he set his house amid the trees, perched on the contours of a cliff, barely intruding upon the forest.

COBAMONG TAKES ITS STYLE from nature. The gardener's touch has been subtle, preserving, respectful. New visitors need time to see that someone has planted shrubs and trees from other continents, built stone bridges and steps, pruned the trees, laid the paths.

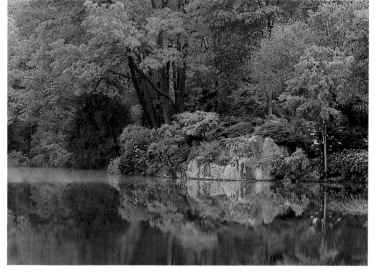

Below the canopy of mature trees, he's planted a shade-tolerant understory of small trees, shrubs and perennials — three levels that repeat the layered structure of the forest, but more richly. Having felled many trees, Nierenberg has enough light in the woods to outdo nature. In the native forest, the understory trees are dogwoods and shadblows. They flower briefly in the bare woods of spring and then are gone. To them, Nierenberg has added cherries, crabapples, redbuds, silverbells, extending the show of color. Beneath the understory trees, he's introduced a wealth of native and exotic shrubs. Here are rhododendrons and mountain laurels, their evergreen leaves relieving the browns and grays of winter. Here are deciduous shrubs — viburnums, aronias, enkianthus, stewartias, azaleas — brightening the garden in spring and summer with bloom.

On the floor of the forest, Nierenberg has laid a carpet of perennials. Amid the hummocks and rocks where streams enter the lake, irises bloom. Shafts of morning and afternoon sun slant across the water and under the trees, lighting up leaves and petals like stained glass.

ABOVE: The Chinese call them "saucer gardens"—sites where the center lies below the sides. On a lake surrounded by hills, the views look across the water to boulders and distant trees. Turn away from the lake, and the interior reaches of the garden stand out against the backdrop of the forest.

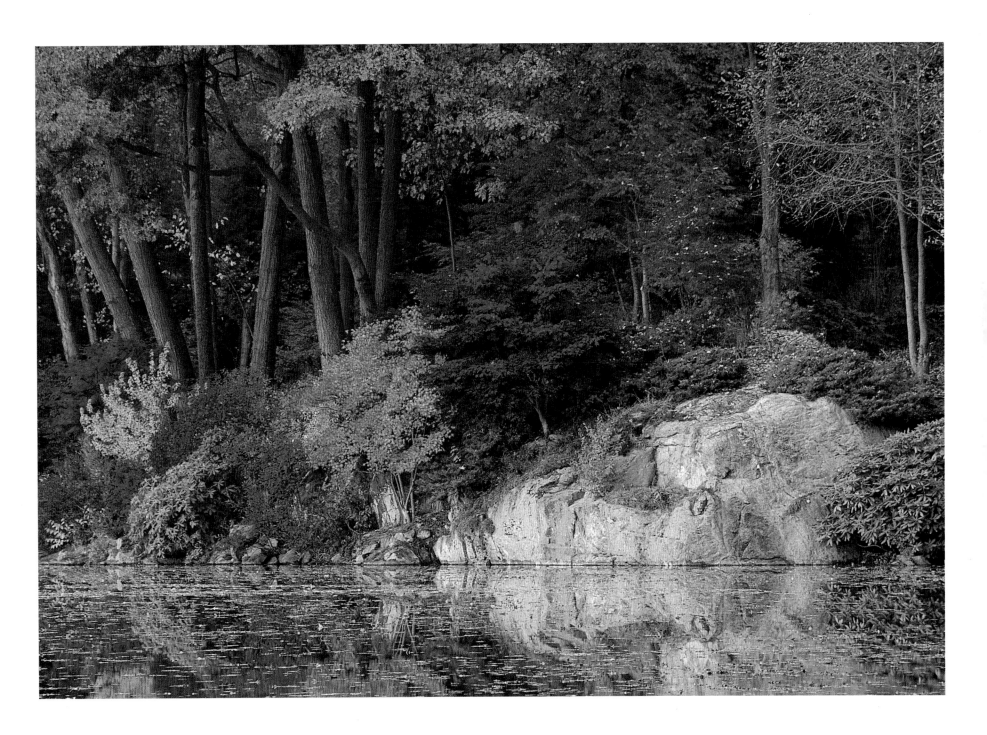

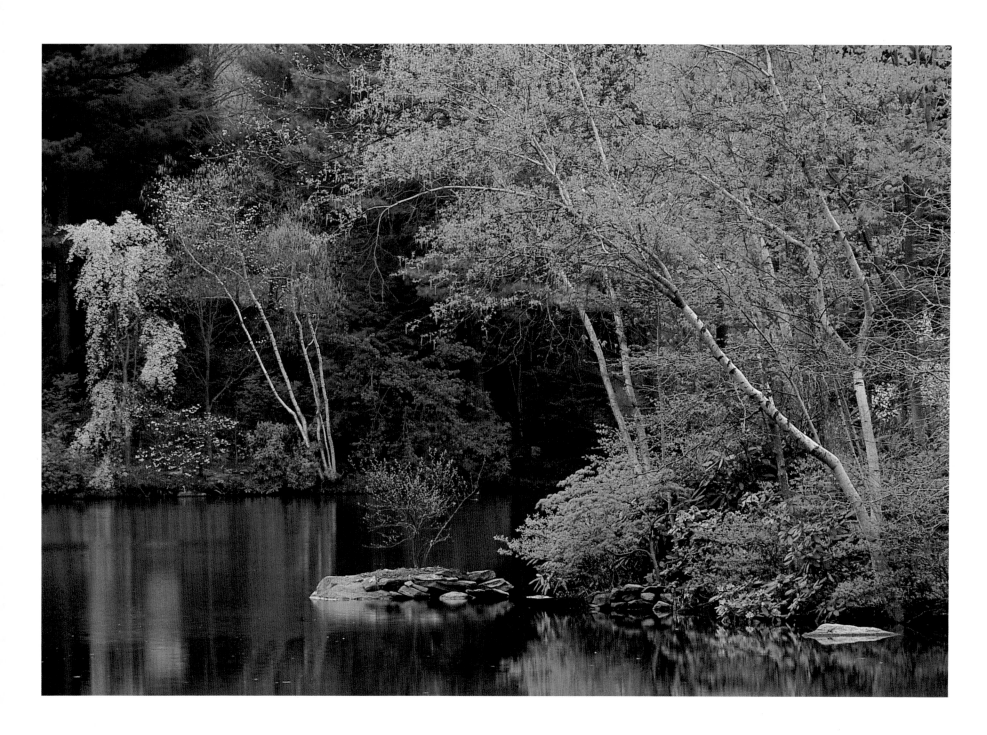

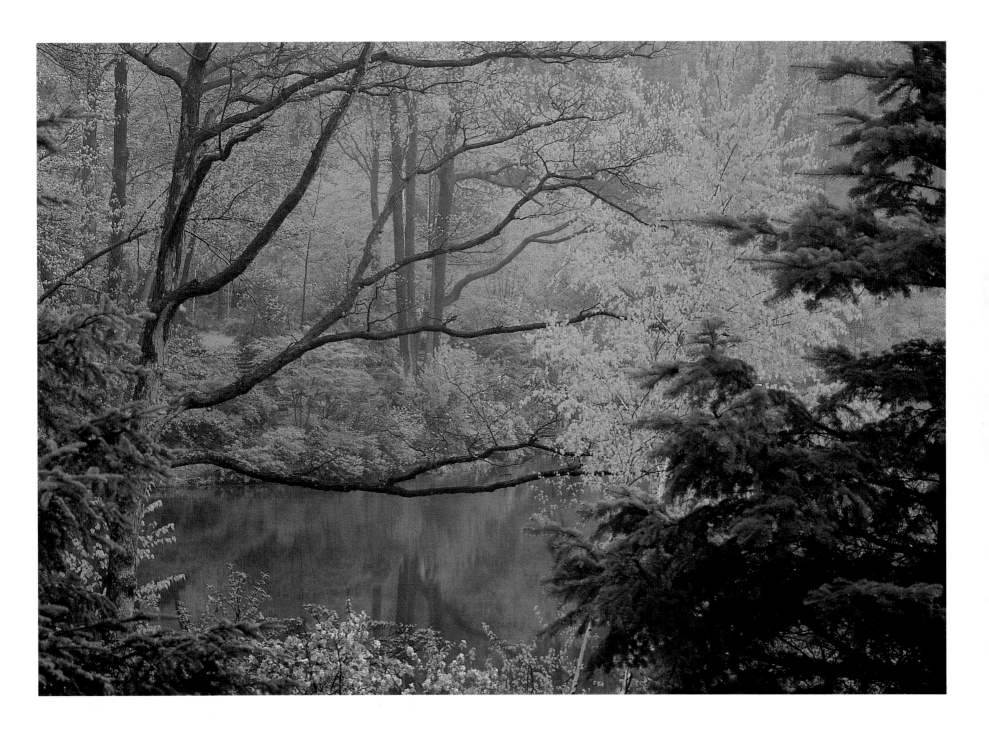

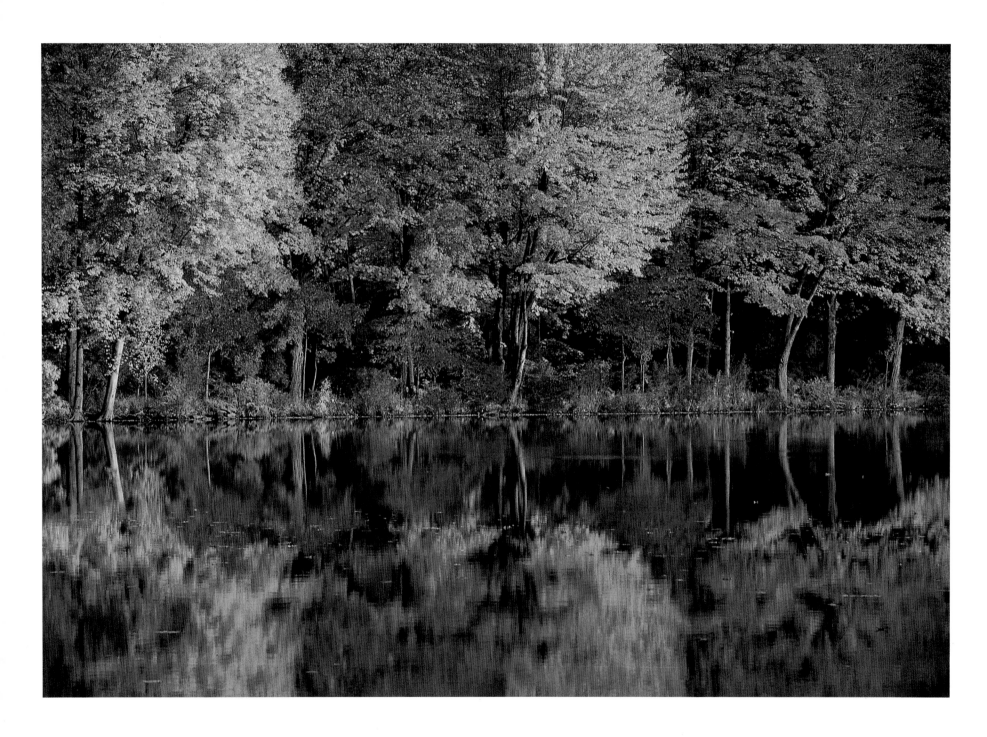

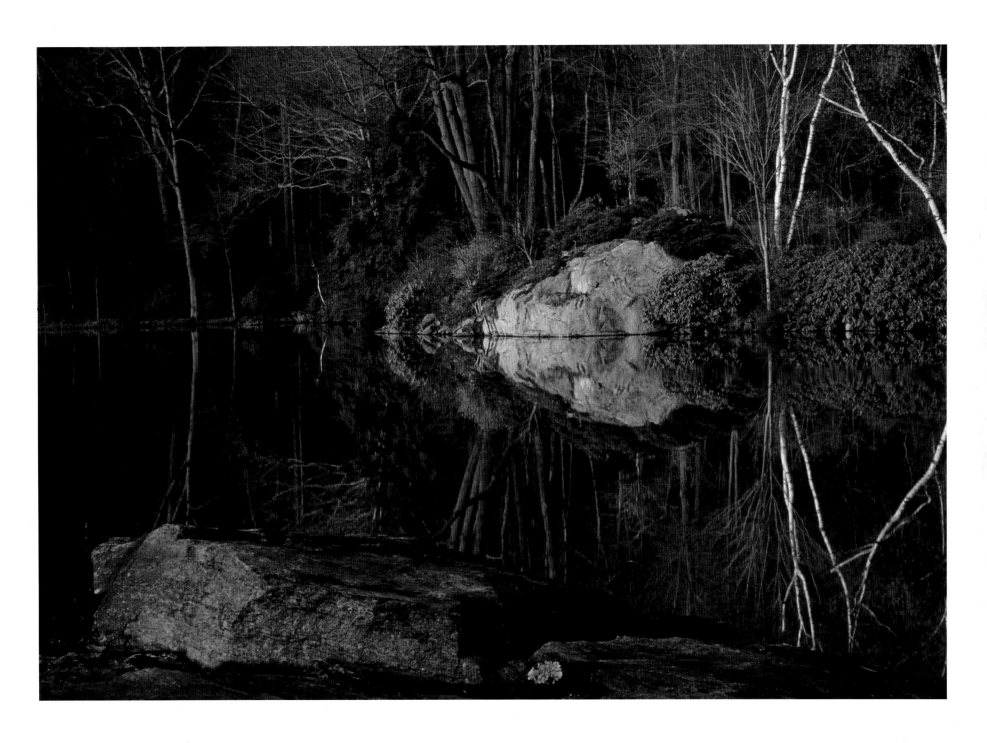

RIGHT: In a region where fall ends with brilliant color,
Nierenberg makes the season more vivid by growing
shrubs and trees from other continents that
blaze as brightly as this centenarian Japanese maple.

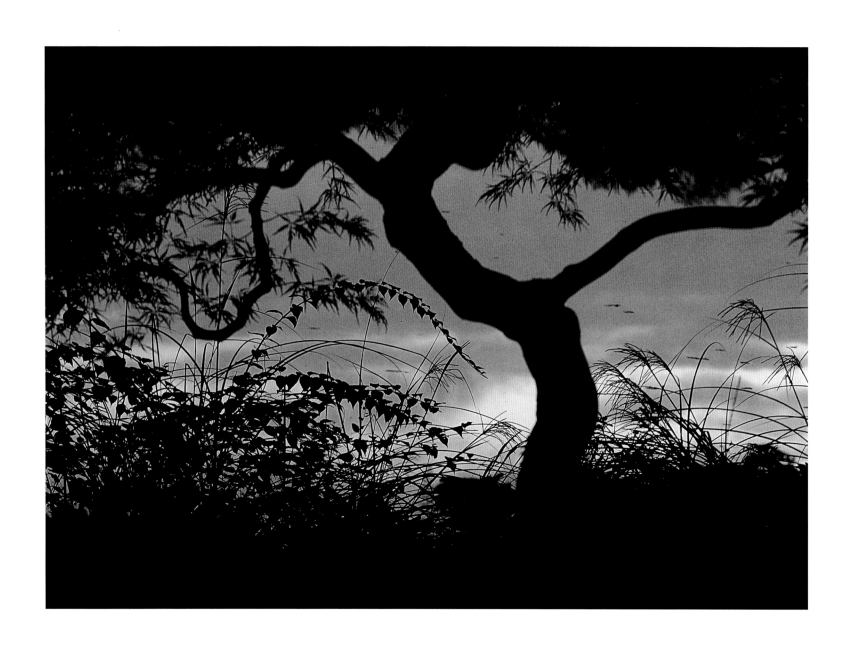

Vistas and Vignettes

THE PATHS AT COBA-MONG tell the story of the garden. They lead the eye before they lead the feet. They give dimension and direction to the garden. They control the pace of a stroll, slowing your feet when they narrow and twist and climb, speeding you along when they run broad and level. They decide your vantage point, bringing you to the foot of a slope to gaze up at a cresting wave of shrubs, turning you away from the lake to admire a ravine, rounding a boulder where a pocket of moss catches your eye.

The paths are barely tracks — so natural they might be the work of hooves, or moccasins. Nierenberg and Malewitz grubbed out the paths with mattocks amid the roots of trees and the knees and elbows of bedrock. Their hand labor spared the landscape that machines would have trampled.

Barely eighteen inches wide, meandering, compacted by the passage of many visitors, the main paths traverse the slopes that drop down to the lake, keeping close to the shore except where boulders and steep inclines oblige them briefly to veer inland. From the main paths, branches lead up ravines passing through a collection of viburnums, up a slope to a vantage point, up a bluff to offer an overlook.

The paths took engineering. Across a marshy inlet, one path rides on a jetty of boulders butted together like the parts of a jigsaw puzzle. Where the paths cross perilous slopes, Nierenberg laid tree trunks across the ground, pinned in place at each end by rocks or standing trees. Then he shoveled dirt behind the trunks, creating ledges across the slopes. The trunks are locusts — rot-resistant trees. Thirty years after Nierenberg placed them, they're weathered but solid. They look like accidents of nature.

The paths have an illusory quality of great age.

OPPOSITE: In any garden, large or small, long views and vistas share attention with intimate vignettes. The eye first ranges far away and then lingers close by on the twisting trunk of a venerable Japanese maple, up to its canopy of star-shaped leaves, and finally resting on the curving blades of grass at its feet.

Flat coins of lichen speckle the stone steps. Duff paves the paths and moss carpets their sides, showing bright green and soft through fallen leaves. A slow, patient plant, the moss seems to say the garden has hardly been touched by man. But Nierenberg has created an illusion. To obliterate his raw handiwork, he dusted new paths with powdered sulfur, making the soil more acidic, a change that favors moss. Within two years moss carpeted the wandering paths.

As in all great gardens, the paths control the rhythm of a stroll. Following the lake's many promontories and inlets, they curve and change direction ceaselessly. They invite by hiding part of the garden around the next bend; then, around the bend, they stop the visitor with surprises. A leisurely amble first quickens, then halts. You may walk steadily, enjoying the path, or stand still for minutes, taken in by the berries of an ash close enough to pick, or by the reflections of maples on the far shore of the lake.

MYSTERY ENRICHES A GARDEN. Walking the paths at Cobamong, with the view ahead always disappearing around a curve, you feel a tug. Something wonderful lies ahead, tantalizing, out of sight. You have to keep walking and see what it is. Nierenberg sustains the natural mystery of the paths by planting shrubs and clumps of trees that screen the next portion from view. Often you can see your path in the distance, across a cove or ascending a slope, but you can't see the twenty feet that lies ahead.

Surprises also enrich a garden: they are the reward for pursuing mystery. At Cobamong, the paths close in, screening the view with twigs and leaves,

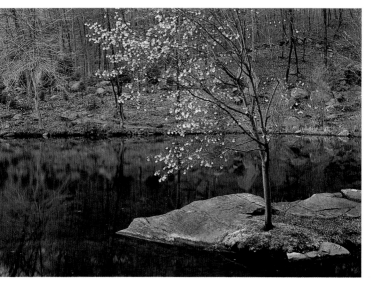

ABOVE: Great gardens often include overlooks, high vantage points that reveal distant vistas. Looking down, a visitor sees a tree growing in a mound of soil that Nierenberg spread on bedrock.

32

and then turn to reveal a hidden vista, a choice Exbury azalea in full bloom, a fork in the path with one branch leading up a hidden glen. Two feet from a turn in the path, you may have no inkling of what lies ahead. You come upon a rivulet burbling under a slab of stone, granite steps curving up a slope, an open glade, a view across the pond of a roofline among the trees. You turn to the side and find a grotto of shrubs, with a stream running between banks of boulders before it plunges in a single sheet two feet wide over the lip of an artfully laid, flat-topped stone.

In a great garden, one sure surprise is a refuge. Hidden and inviting, refuges are places to sit and see without being seen, out of sight and safe behind and to the sides. In a formal garden, the refuge might be a bench set in an alcove pruned part-way into a tall hedge. In an informal garden like Cobamong, the refuges are rustic. One is a seat in a cleft of bedrock, made with a slab of rock spanning two stone pillars. The bedrock rises high behind the seat, muting the sounds of the garden and stilling the wind. Several refuges are half-rounds cut from the trunks of long-felled trees, set with their flat sides up for a seat. Weathered and mossy, they wait in the sheltering lee of shrubs as big as a garden shed.

The most splendid refuge at Cobamong is high above the lake on the brow of a granite cliff. Nierenberg built a twisting stone stairway up the hill beside the cliff, setting granite boulders into the slope by hand. From below, the stairway is invisible, lost in a jumble of boulders and rocks strewn by the glacier on the hillside. The climb is steep and dizzying. At the top, you cross

ABOVE: Details count, and every part of a garden deserves attention. When visitors stroll by, they find a carpet of flowers blooming in the shelter of jumbled boulders, with young trees holding their last red leaves aloft.

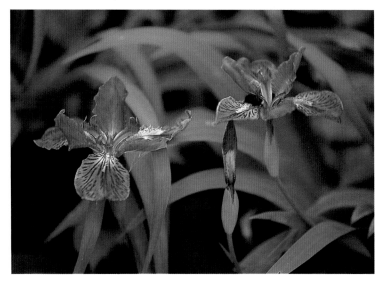

the brow of the cliff with care and then you discover, perched at the edge, a weathered, near-decrepit Adirondack chair pointed at the lake.

Great gardens often have overlooks, vantage points where a visitor can survey broad vistas. Gardens need high spots — outcroppings, knolls, terraces, steps—and garden paths must lead to them because visitors need to take measure of their position, relish their progress, and look for opportunity ahead. Overlooks also soothe an atavistic impulse to check for danger. At Cobamong, the paths turn away from the lake many times to ascend the slopes and gain a vantage. There, you stop without thinking at the crown of a hill or the crest of a boulder to survey the horizon, to see what lies ahead, to recall the path behind.

Cobamong combines vistas and vignettes, another trait of great gardens. When Nierenberg plants a stretch of shoreline, he must design for strollers who pass on the land side within ten feet, and strollers who will see the same shoreline from the water side one hundred yards away, a vantage point that reduces trees and shrubs in size and doubles them in the mirror of the lake.

The garden within ten feet of the path is a succession of vignettes, intimate and detailed. Between the moss-covered trunks of two oaks, a hosta with white and green leaves sends up a cluster of flower stalks. Under the spreading canopy of a Japanese maple, ferns overlap their arching fronds. Irises bloom at the water's edge.

MANY TREES along Cobamong's shoreline lean out over the water and then arch upward in graceful curves. Because their canopies extend far out over the water, the trees lend the path a grottolike feel: you walk in deep shade looking under overhanging

ABOVE: Gardens reward a meditative eye. Close at hand, irises spread their petals as if to take flight, revealing velvet texture and streaks of vivid color.

leaves to sunlight and the far shore. Seen across the lake, the arching trunks, especially the pale trunks of birches, stand out from the surrounding trees, and make the lake look timeless, as do the leaning riverside trees in early American paintings of primeval forest.

But it was Nierenberg, and not nature, who created the leaning trees along the shoreline. He starts with good-sized trees, fifteen feet tall or more. He may buy the tree at a nursery, or he and Malewitz may dig it up from the garden, a heroic feat for two gardeners working with hand tools. They use straightforward methods: they spade up the roots, clean off most of the dirt, and wheelbarrow the tree to its new home — imagine the balancing act on a narrow path over hill and dale. Then they set the new tree in place at a steep angle, sometimes as far over as forty-five degrees.

When Nierenberg leans a new tree over the lake, it looks odd for a few years. The trunk is straight, and the top of the tree grows upward. Then, improbably, the once-straight trunk begins to arch. It shouldn't happen, given the biology of trees. On an upright tree, the trunk merely adds girth with the years. But somehow Nierenberg's leaning trees eventually bend their trunks. Any gardener who loves the look of a gracefully arching trunk should consider experimenting with Nierenberg's technique: perhaps a willow on the bank of a stream, or an oak near the foot of a slope.

THE VISTAS AT COBAMONG are unusual. In most gardens, the long views sweep first across the garden. At Cobamong, they sweep across the lake, so that the first plants seen are far away and small to the

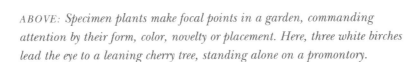

ABOVE: Specimen plants make focal points in a garden, commanding attention by their form, color, novelty or placement. Here, three white birches lead the eye to a leaning cherry tree, standing alone on a promontory.

eye. In other gardens, if the gardener has a lucky site, the long views extend to distant borrowed landscapes — a range of hills, the treetops of a forest. Cobamong has no borrowed scenery. It is a secret world. The vistas stop just beyond the shore, at the sheltering woods and hills.

To lend color and shape to the vistas across the lake, Nierenberg uses two methods: he plants the same shrub or tree in groups that are large enough to hold the eye, and he plants striking shrubs and trees that stand out on their own. Both methods are common enough in gardening to have names. Plants that stand out and command attention are called "accent" or "specimen." Intentionally grouping like plants is called planting in "masses" or "drifts."

Cobamong shows you that drifts and accent plants can enliven any garden, provided you take scale into account. In a small yard, the biggest drift might be six coreopsis plants, their yellow flowers waving eighteen inches high. The plants are small and the drift is small, but the scale suits the garden. A visitor to Cobamong sees a similar effect across the lake when five Japanese cherry trees are covered with pink flowers in spring. The cherries are ten times taller than coreopsis plants, but seen from afar, with forest and hills rising above them, they spread a proportionate scrim of color.

ACCENT PLANTS MUST HAVE PRESENCE. They have to stand out from their companions by size as well as by character. In most gardens, to maintain scale, the accent plants are under head-high — big grasses, shrubs with variegated leaves, dwarf conifers, small Japanese maples. But at Cobamong, to match the scale, the accent plants are full-sized trees. For instance, amid

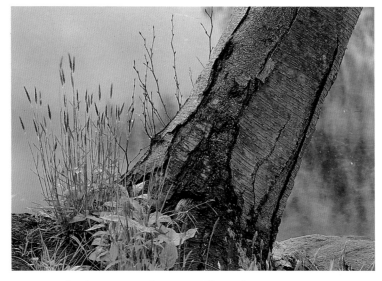

ABOVE: Gardens engage the senses. The eye feasts on color, line and texture, while beside the path the curve of a tree trunk, sheathed in fissured bark, invites a lingering touch.

the hummocks at the marshy mouth of a stream, Nierenberg planted a bald cypress that is now thirty feet tall. As a lone upright plant in a low boggy setting, the cypress shows off its distinctive cone shape and light green color during the growing season, then yellow in fall, and bare branches in winter.

The most common accent plants at Cobamong are birches. Nierenberg plants both canoe birch and white birch, species with near-white bark that tend to lose their lower branches early, growing tall, slender trunks with a high-up plume of leaves and branches. They appear repeatedly along the shoreline. Seen from across the lake, their pale trunks contrast dramatically with the dark shade of the forest which looms mysteriously behind them.

The birches also contribute to the intimacy of paths at Cobamong. Seen close up, these trees invite touching. Their bark is tight and smooth, giving the trunks the look of columns. Nierenberg places birches and other trees with beautiful bark — paperbark maples, Japanese dogwoods, cherries — close by the path, often at turns and natural pauses. One of the finest is the lacebark pine from China. The trunk is startling in color, a pale gray to white on mature trees. Nierenberg first saw the tree while visiting the palace of Sun Yat Sen in Nanking. Sitting above a ravine, facing a canopy of lacebark pines, he glanced down and saw chalk-white trunks. A perfect addition to Cobamong. Another tree that invites touching is the river birch, whose bark peels away in papery horizontal bands with frayed and curling ends that catch the light when the sun is low in the sky.

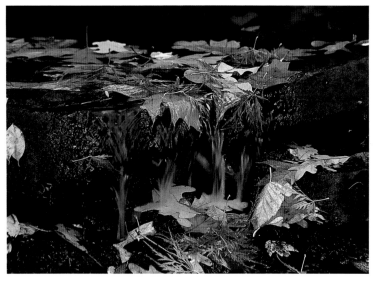

ABOVE: Fortunate accidents seem to multiply in the garden, where nature embellishes the gardener's handiwork. Fall tints the leaves and strews them in collages that rival the richest colors of spring.

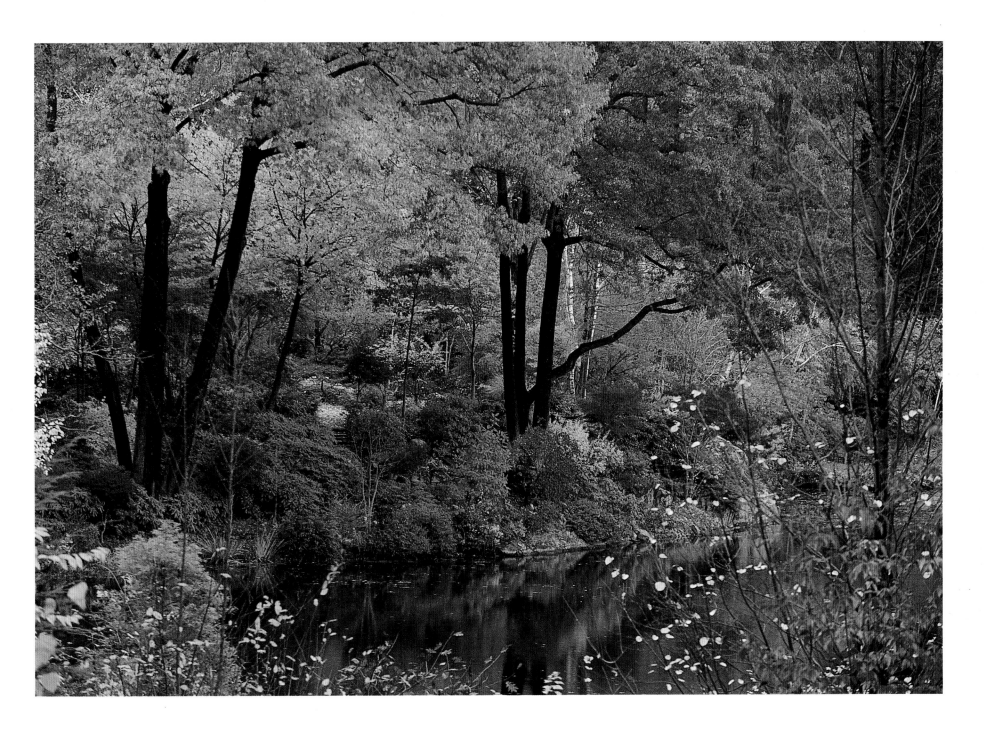

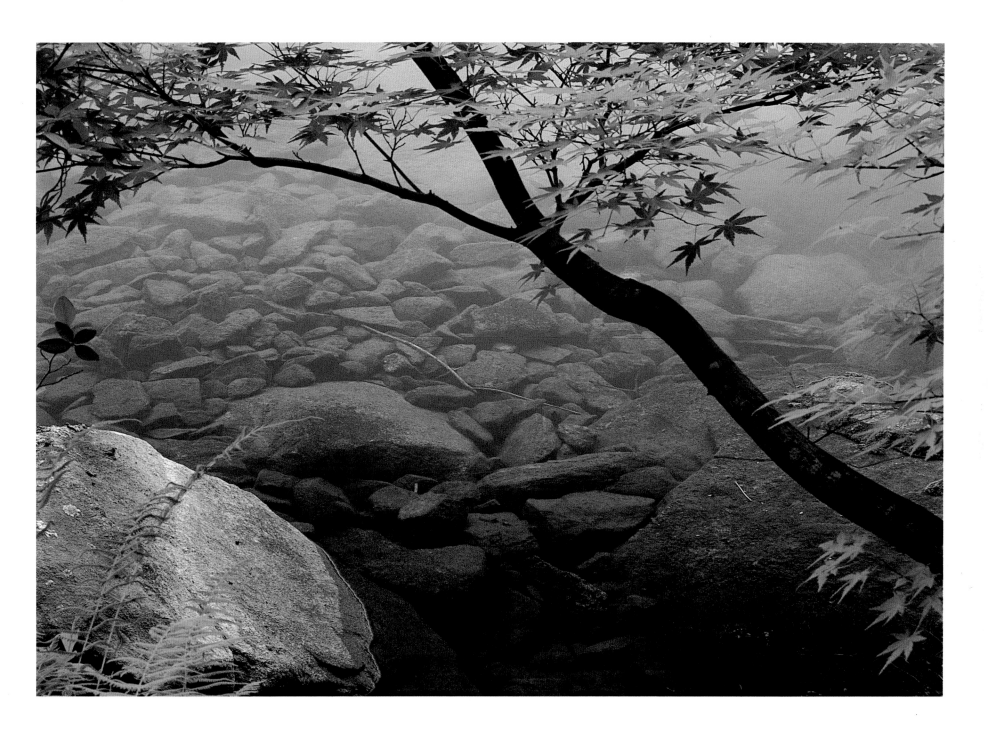

41

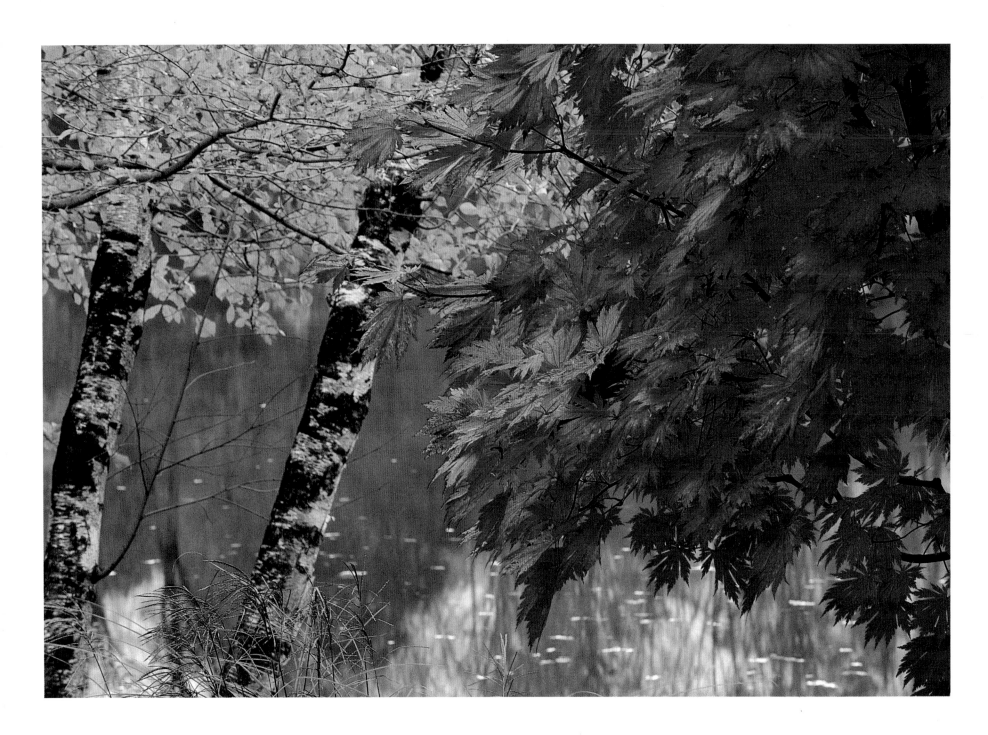

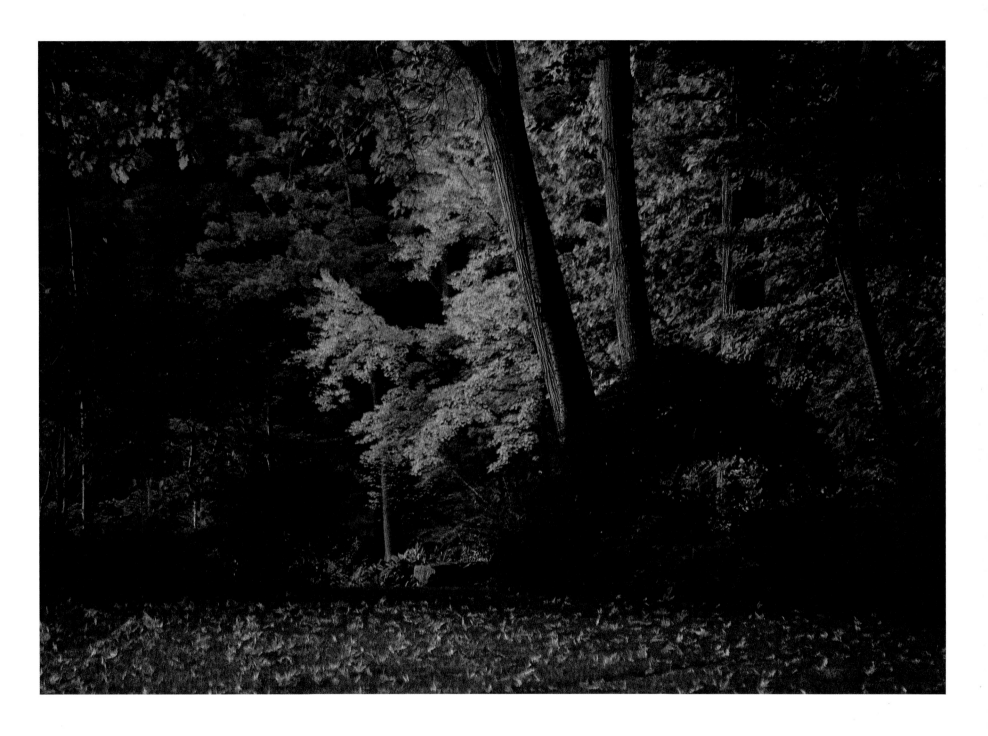

43

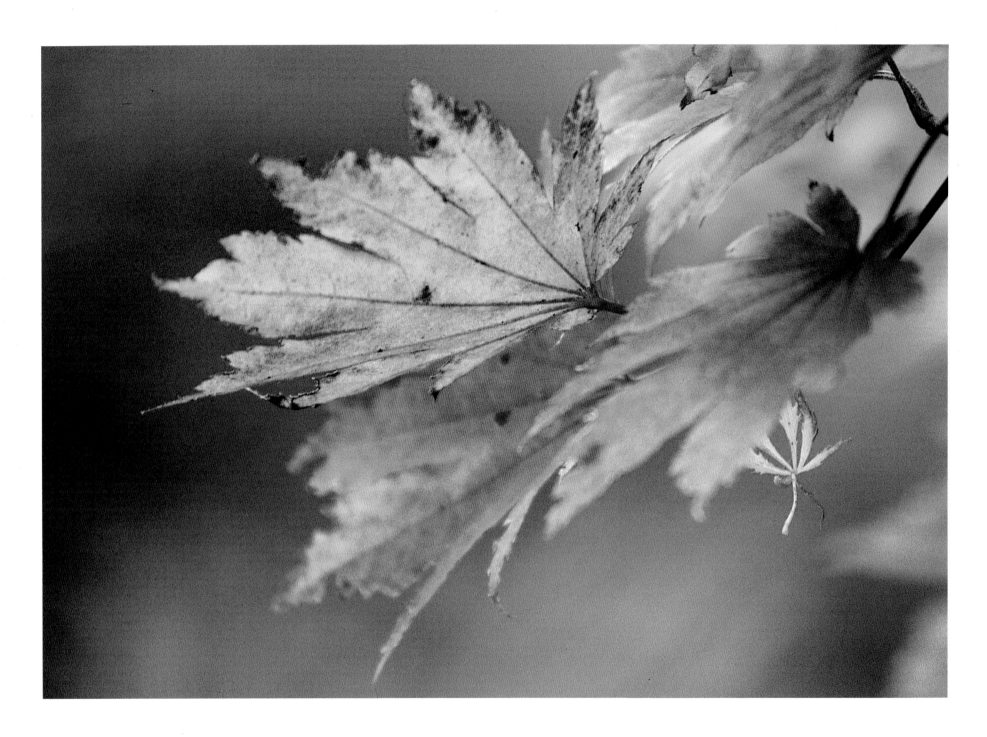

In the garden, there's an art to seeing. Stand in one place, wait without expectations, and the bright red of winterberry emerges from the tangle of twigs and leaves as if strung on loops of string.

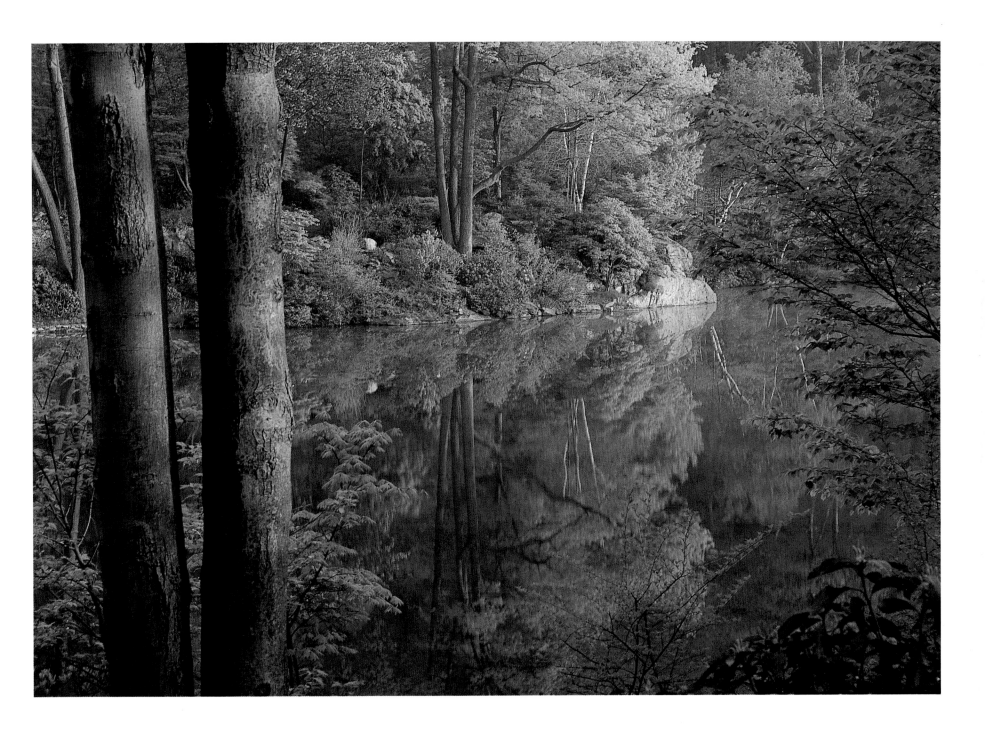

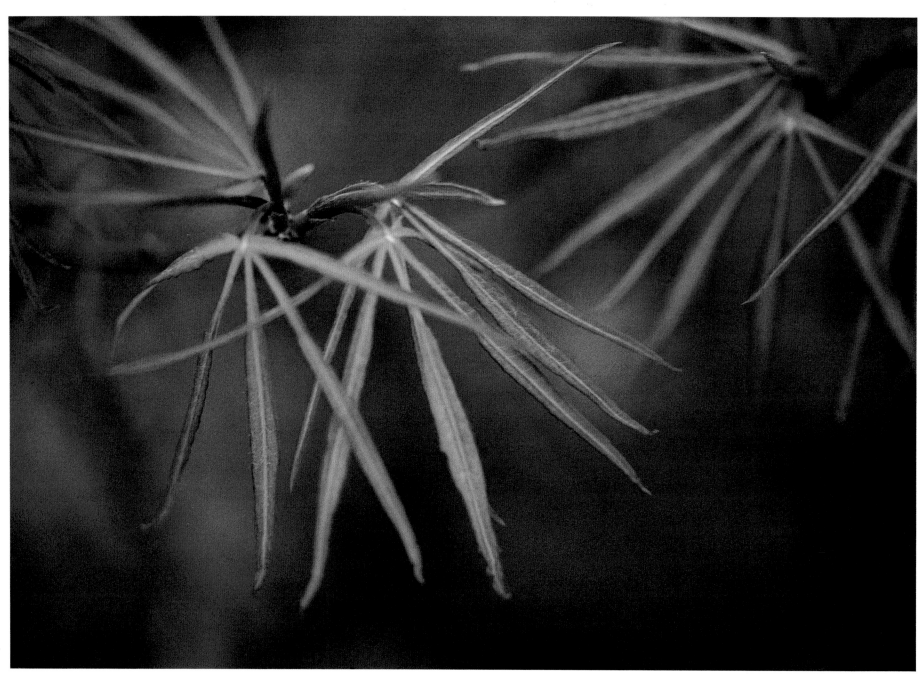

Gardens gain distinction from their vivid plants, selected in the wild by collectors or bred for color, form and flower by enthusiasts and nurseries. Here a chance of nature has reduced the broad lobes of a Japanese maple leaf to slender spears.

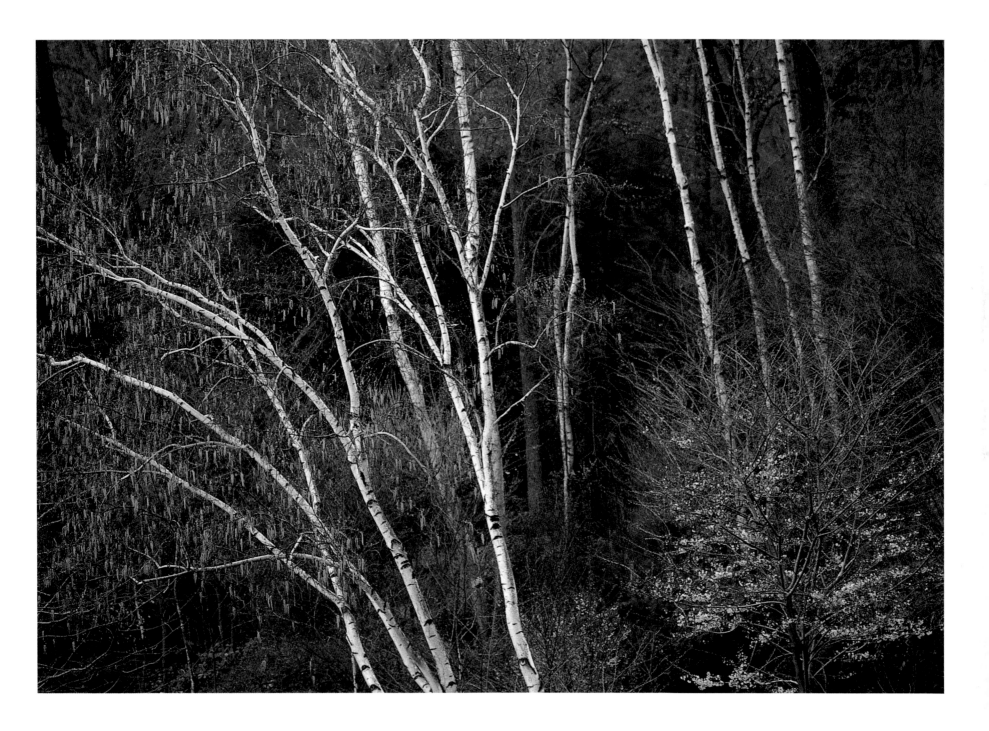

49

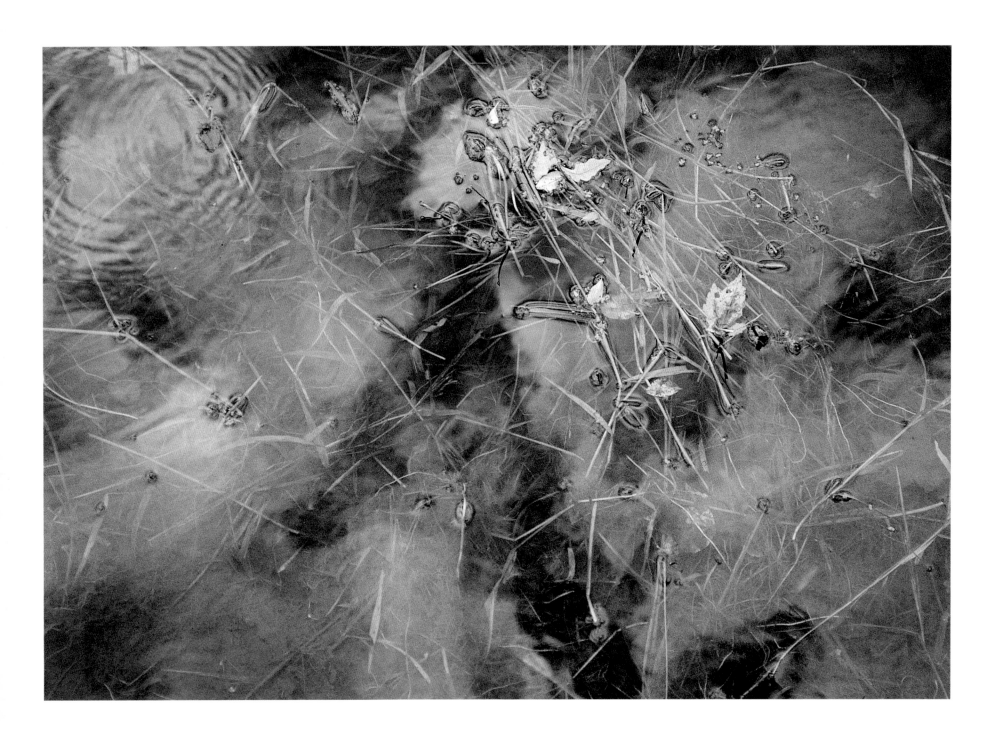

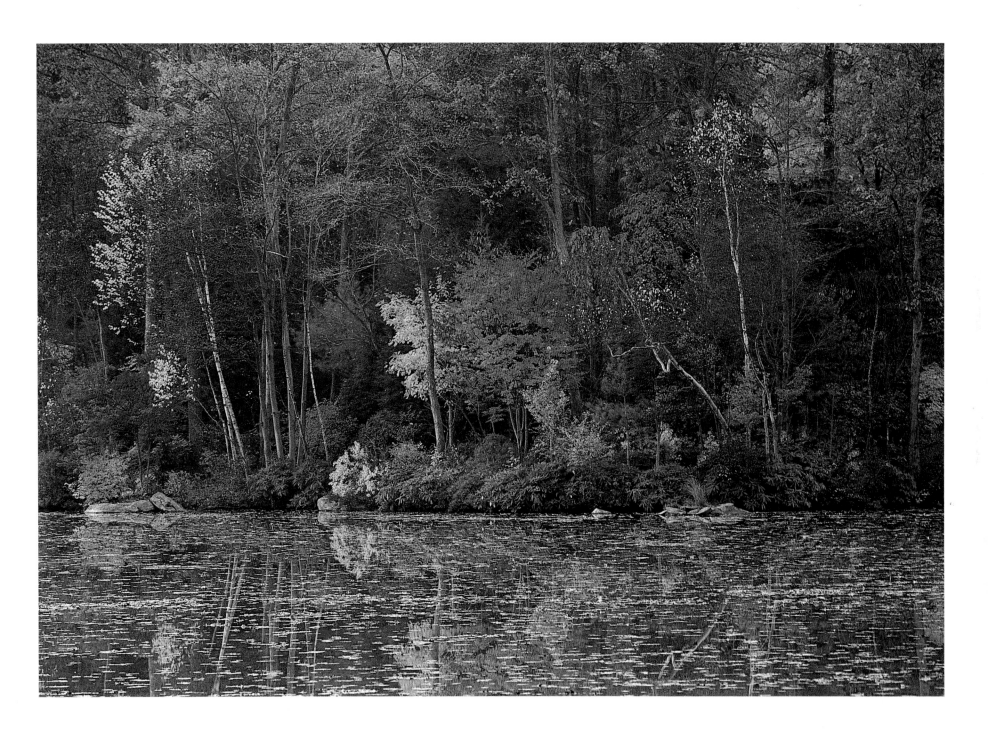

51

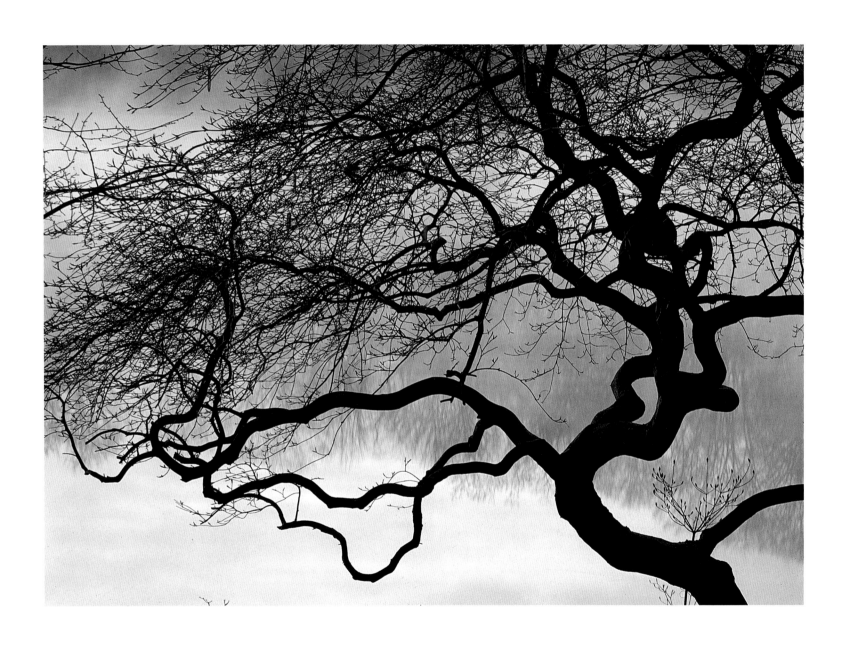

The Seasons

ALL GREAT GARDENS, even those with informal styles, depart tangibly from nature because gardeners want plants that attract the eye and consort agreeably. Gardens assemble in one place the vivid moments and scenes that nature scatters widely—the carpet of flowers that paint alpine meadows in spring or color the desert after a rain, the flaming leaves at the peak of fall in New England, the eruption of bloom in the rhododendron glades of the Appalachian mountains, the drifts of white trunks in birch forests. At Cobamong, the seasons of the year succeed each other more distinctly and with greater verve than they do in the native forest.

Nierenberg, like most gardeners of passion, avidly pursues the plants that suit his taste. To the gardener, the world is a cornucopia of garden plants. The goal is to assemble the choicest and the most complementary — plants that offer grace, color, a long season of interest, uncommon toughness, contrast, exoticism. One kind of rhododendron alone won't do when the world offers hundreds of species, when nurseries sell a panoply of colors and shapes created by the art of plant breeding. At Cobamong, as in a museum, visitors tour a collection of masterpieces, not nature's usual local assembly of survivors bent on survival.

Gardeners who seek choice plants become connoisseurs of specialty nurseries, art dealers of gardening, who offer plant collections that represent centuries of exploration, collecting, and breeding. They sell tulips with pedigrees that hark back to the Dutch fanciers of the sixteenth century. They propagate the native franklinia tree, named for Benjamin Franklin, first discovered in the 1700s on the bank of a river in Georgia. Never seen in the wild again, the franklinia survives now only in cultivation, and its

OPPOSITE: The seasons in the garden progress by a calendar of signs as precise and clear as the face of a watch. Shorn by winter, dormant until spring, the Japanese maple reveals its twisting limbs.

53

wide, white flowers grace gardens across the country, many of which are far north of its native range.

Over the years, Nierenberg would often buy plants from a specialty nursery, then start up a correspondence with the owner, and eventually visit in person. Catalogs are useful, even enticing, but nothing compares to seeing thousands of young plants and choosing the best in the company of the nursery owner. In spring, when hundreds of rhododendrons paint Cobamong with intense color, the show owes a debt to Greer Gardens in Eugene, Oregon, where over the course of thirty years Harold Greer has assembled a world-wide collection of rhododendron species and hybrids. When the yaku-shimanum rhododendrons flower, Cobamong becomes an outpost of the Japanese island near Okinawa that is the home of the species. Nierenberg's plants, among the

first in the United States, came from Van Veen Nurseries in Portland, Oregon. In fall, when the Japanese maples turn red and orange, they recall a day in the early 1970s when Nierenberg saw hundreds of cultivars at the small nursery of J. D. Vertrees and selected the young plants. And more than one hundred species of trees and shrubs were chosen, one by one, from the large collection of rare and exceptional plants at Princeton Nurseries in New Jersey.

Because Nierenberg has artfully chosen and placed his plants, the drama of four distinct seasons unfolds more vividly at Cobamong than in the natural forest. In the natural forest, at the start of the gardening year, dogwoods and shadblows bloom like clouds amid the leafless branches of still-dormant trees. Spaced far apart by the vagaries of nature, the early bloomers make an ethereal impression, like streamers of fog. At Coba-

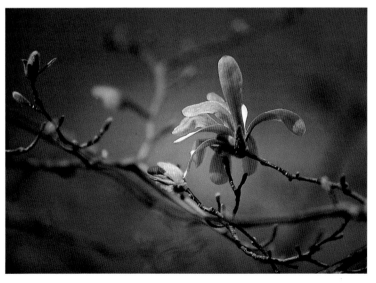

ABOVE: Like music, the seasons mysteriously arouse deep emotions. In early spring, the unfolding buds of a magnolia risk their fragile color amid the gray, skeptical twigs of the forest.

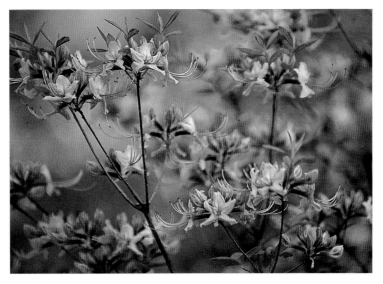

mong, Nierenberg has grouped them together to make an even bolder show. Their canopies merge in swaths of color too rich to be natural. And they are joined by a fellowship of spring-blooming shrubs and trees from other continents that brighten the woods with non-native colors. The cherry trees that Japan reveres for their transient beauty show broad, hazy strokes of pink. Azaleas light their firecrackers, turning themselves into billows of purple, pink, white, cream, yellow and red. In the spots that get a little sun, crab apples are covered with pink and white flowers.

ON THE FLOOR OF THE FOREST, the ephemeral flowers of spring spread more densely than in nature. At mouse height, snowdrops dangle their white bells from arching stems. Crocuses blanket nooks along the path with goblets of white, purple and yellow. Bloodroot, found creeping along pockets of soil in the rocks, holds up its pure white daisies.

No matter what size the garden, spring ephemerals manage to hold their own. You plant them in drifts that suit the size of the garden, and when they are happy, they naturalize, adding a new generation every year. In a city garden, two dozen crocuses or daffodils are plenty for a first planting. At Cobamong, Nierenberg plants them by the hundreds and they increase ecstatically, making two bulbs from one or branching underground, so that year after year the show grows richer. In a rocky glade that is like a cathedral with a Persian carpet on the floor, thousands of daffodils lift their cheerful trumpets. Here, Nierenberg has removed most of the shrubs and trees, leaving one of the garden's rare clearings barely interrupted by a few, dignified oaks that are as widely spaced as the

TOP: Spring yields the tenderness of birth and infancy, when azalea flowers lift their arching stamens, laden with pollen.

rooms of a house. Their trunks rise branchless and straight, and their canopies entwine fifty feet overhead. White and yellow, the daffodils glow in the glade, and the delicate light they reflect seems to hang in the air, held aloft by the trees.

AS SPRING UNFOLDS, the show of color builds to a crescendo. Andromedas and redveins, shrubs that are close kin, wave tresses of small bell-like flowers. At the tips of their branches, mountain laurels unfurl dense clusters of bloom. Each small, scalloped flower crowds

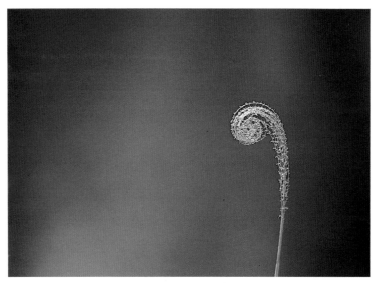

its neighbors, jostling for room, struggling to open wide and release the stamens which are trapped in the petals. The stamens are bent like saplings weighted with snow. When the petals release them, they spring up, lofting their pollen into the air. Native and hybrid azaleas, which are deciduous shrubs,

bloom with great masses of flowers. Nierenberg has strategically planted them in drifts, grouped by color, so the slopes and nooks of the garden bloom by turns, in white, pink, violet, purple, red.

The crescendo of spring color gives way to the calm of summer, when the leaves of the forest reach their dullest green, when heat and haze overtake the garden. But in summer, as in the other seasons of the year, Cobamong remains more vivid than nature. Cobamong has many of the relatively rare shrubs and trees that flower in summer. The oak-leaf hydrangea flowers then, producing huge white pom-poms at the tip of long stems. Nierenberg favors a cultivar called "Snow Queen." On most hydrangea cultivars, the stems cannot hold the flowers high when rain makes them heavy with water. The stems bend like the ribs of an

ABOVE: In the symphony of spring, every plant makes an entrance. Just above the forest floor, nearly lost in the din of bursting buds and erupting leaves, a spiral of old grass remains coiled for winter protection.

56

umbrella and the flowers hang upside down in a tattered skirt. On "Snow Queen," the stems are sturdy and hold the flowers upright, even after a heavy rain. Nierenberg also likes the Japanese snowbell, a shrub that rarely grows taller than twelve feet and blooms with pendant white flowers in summer. In the same season, Cobamong offers the odd, mistlike flower clusters of the aptly named smoke tree, as well as the large, blowsy white flowers with vivid yellow stamens of the stewartia, a shrub graced with a multicolored, flaking bark.

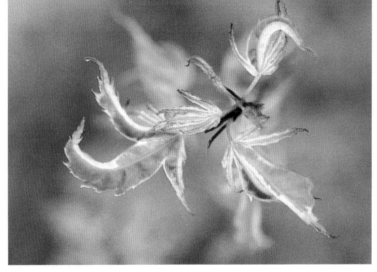

In summer, Cobamong's dense stands of ground cover break into bloom. During the first few years, Nierenberg tried mulching and weeding to maintain the garden. They were effective measures, but took far too much time on twelve acres. Besides, Nierenberg did not like the look of exposed mulch.

Instead he decided to carpet the garden floor with shade-tolerant plants.

IN A SMALLER GARDEN, the ground covers would be plants under six inches tall — ajuga, vinca, pachysandra, creeping phlox, lamium, euonymus, ivy. At Cobamong, where the scale is larger, the ground-cover plants have to be bigger. In any case, the usual vinca and others would take too long to spread and demand too much weeding.

So Nierenberg chose plants that in many gardens are the backbone of the perennial border — hostas, peonies, astilbes, daylilies, bleeding hearts, irises, ferns. In summer, hostas and daylilies send up wands of trumpet-shaped flowers. Bleeding hearts make mounds of delicate, fernlike leaves and festoon themselves with gracefully arching stems that dangle pink heart-

ABOVE: No color in the garden rivals the soft hues of leaves as they first emerge in spring, just before the dusty rose of new growth gives way to the practical green of maturity.

shaped flowers. At the water's edge, happy in the sun, irises lift their ornate flowers. On stiff, upright stems, astilbes make hazy, many-branched clusters of tiny pink or coral flowers.

In fall the leaves turn, offering Cobamong's most luminous show of color. Half on the trees, half on the ground, yellow leaves warm the paths with reflected light. The colors of fall linger, sweeping across Cobamong by turns. First, the gum trees turn crimson and orange, then the hornbeams turn pumpkin-red, and the shadblows turn orange-yellow. Swamp maples are swathed with brilliant reds, and then sugar maples produce a collage of reds and yellows. Finally the ashes turn orange, the dogwoods turn soft red, and the dawn redwood turns yellow and brown.

In the early years of the garden, the native fall colors inspired Nierenberg to introduce shrubs and trees that would make the season even more vivid. Now ginkgos wave their golden fan-shaped leaves. Blueberries and maples blaze red and purple. The redvein, whose branches ascend in repeating outward curves, colors gradually in fall, so that leaves of yellow, orange, scarlet, and green mingle on the same shrub — a time-lapse summary of summer giving way to winter. Aronia turns bright red in fall, complementing the scarlet of its ash-like berries. Swamp maples abound. Their canopies at a distance look like a single swath of red. Nierenberg favors two especially showy cultivars, "October Glory," which holds its red leaves well into the fall, and "Red Sunset," which colors earlier than other swamp maples.

AS COLDER WEATHER SETS IN, Cobamong offers more subtle pleasures. The chokeberry illex and viburnum display their crops of berries. The clumps of perennial grasses wave brown stalks and seedheads. A file of Serbian spruces, dark green columns, stands out amid the bare branches of the forest. Birches form white lines on the gray backdrop of winter. The shrubs that hold their leaves year-round—leucothoe, azalea, rhododendron, mountain laurel, andromeda—make green mounds below the trees. When snow falls, the hemlocks and pines become ghosts.

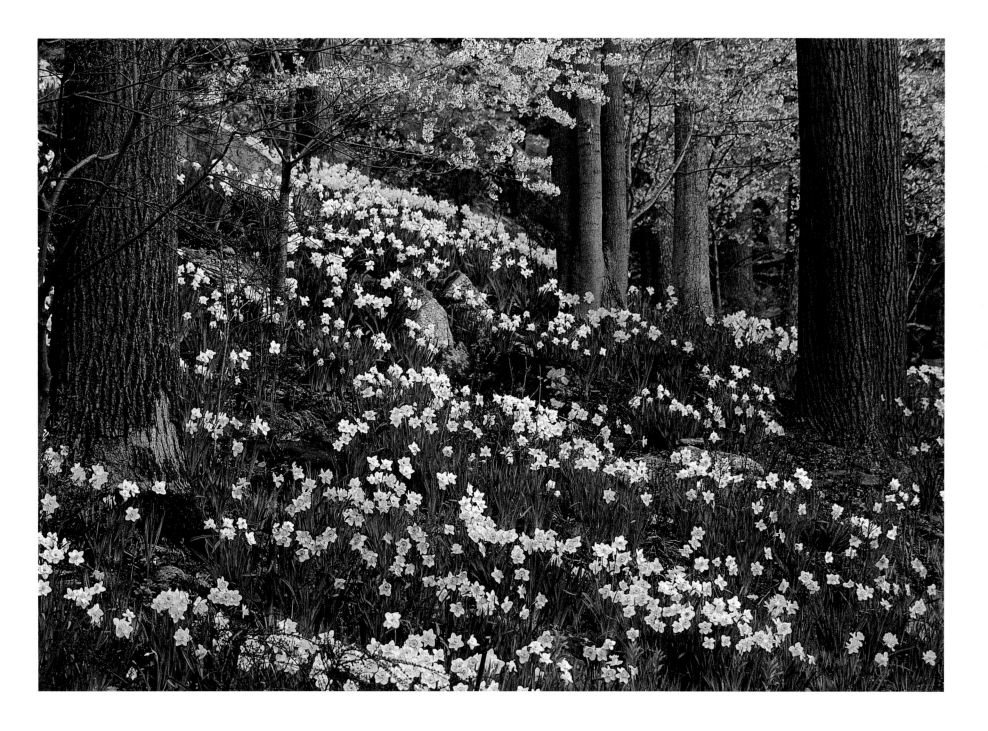

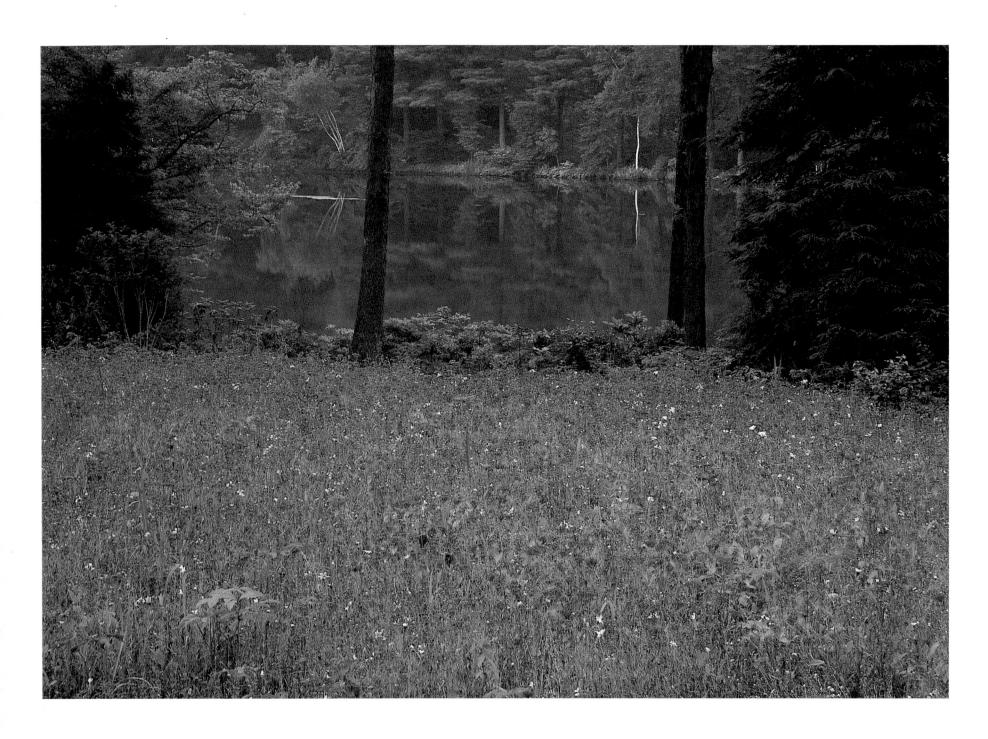

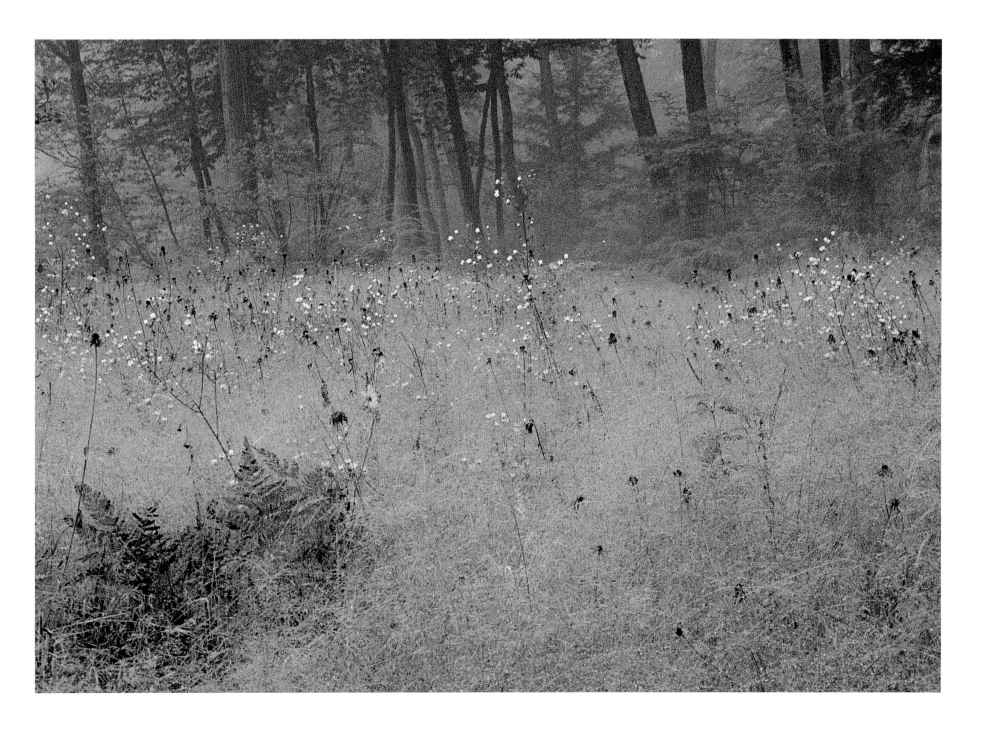

61

RIGHT: The seasons sweep across the garden in precise but fleeting moments, as when the transient pink of a flowering cherry shares a pastel tenderness with the green of newly emerged oak leaves.

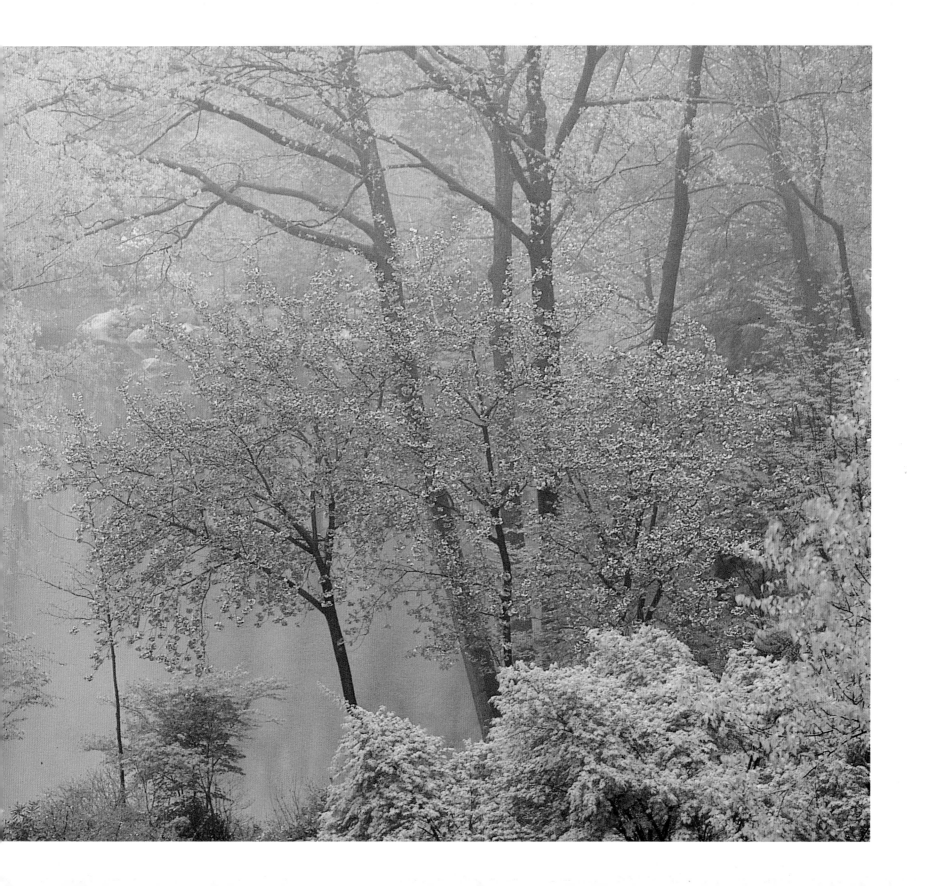

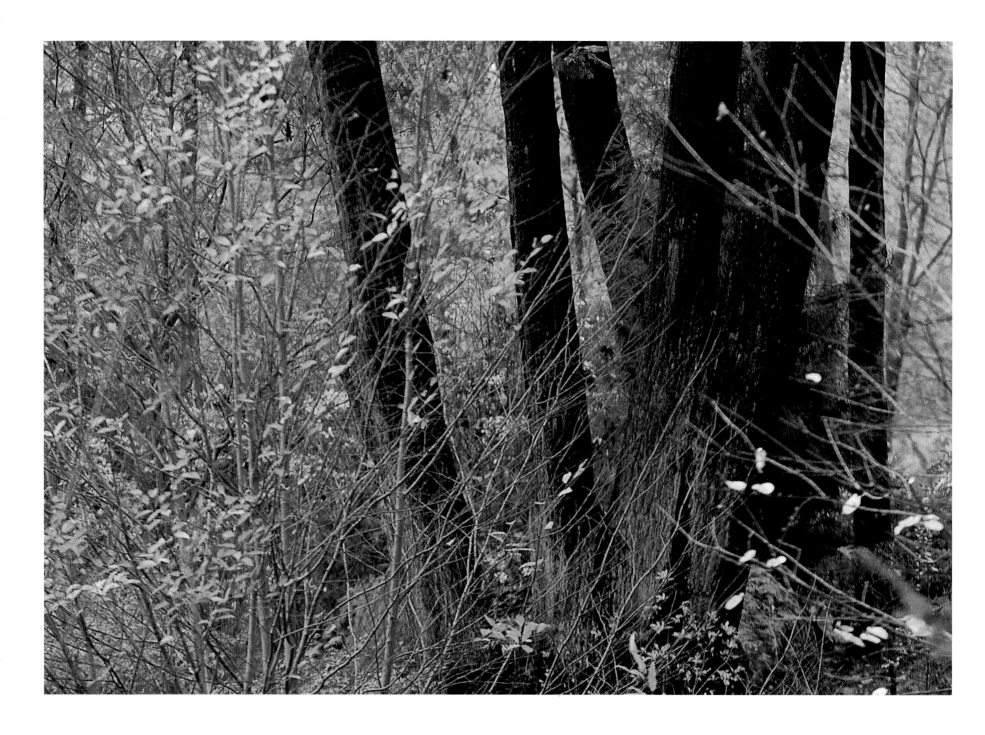

64

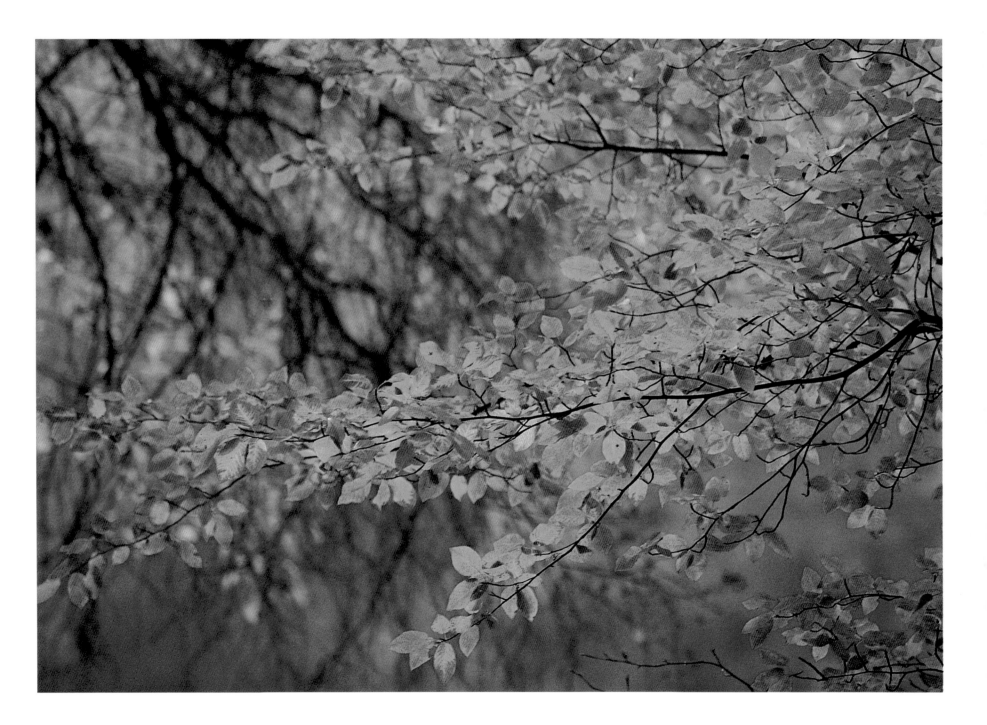

65

RIGHT: Scale makes color effective. In a small garden,
one dogwood can paint the fall red. In a garden that follows
the expanse of a lake, the same effect demands a sweep
of dogwood trees, planted close together, with
the white birch trunks and yellow leaves for contrast.

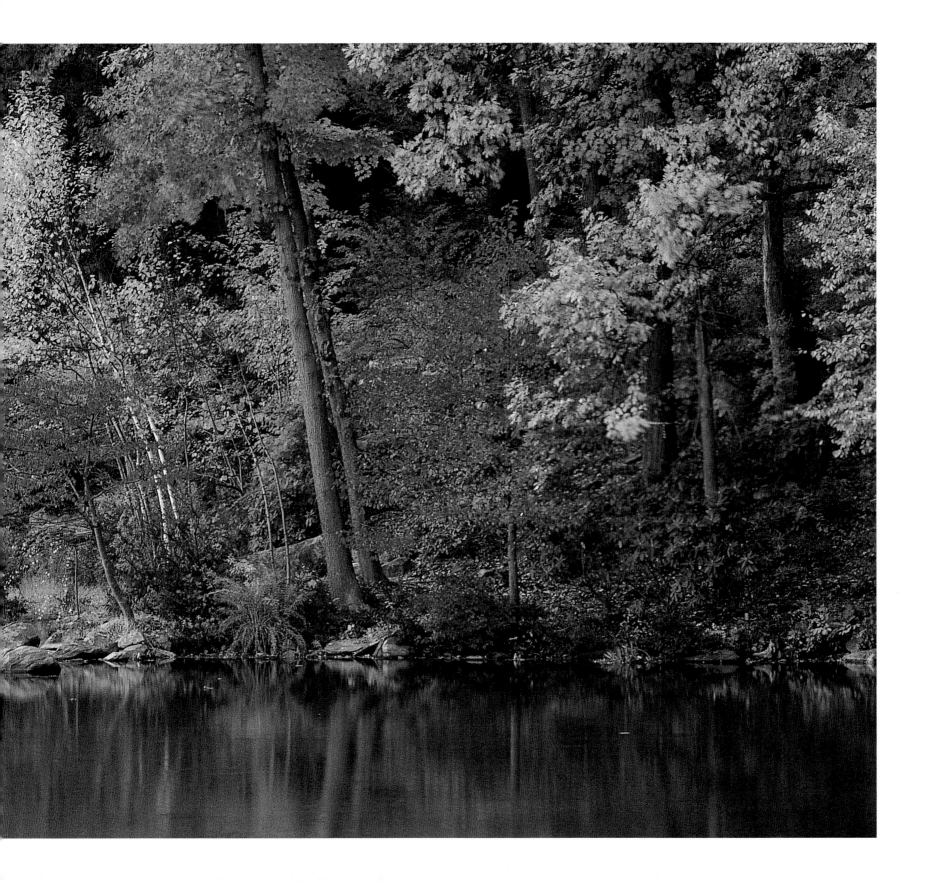

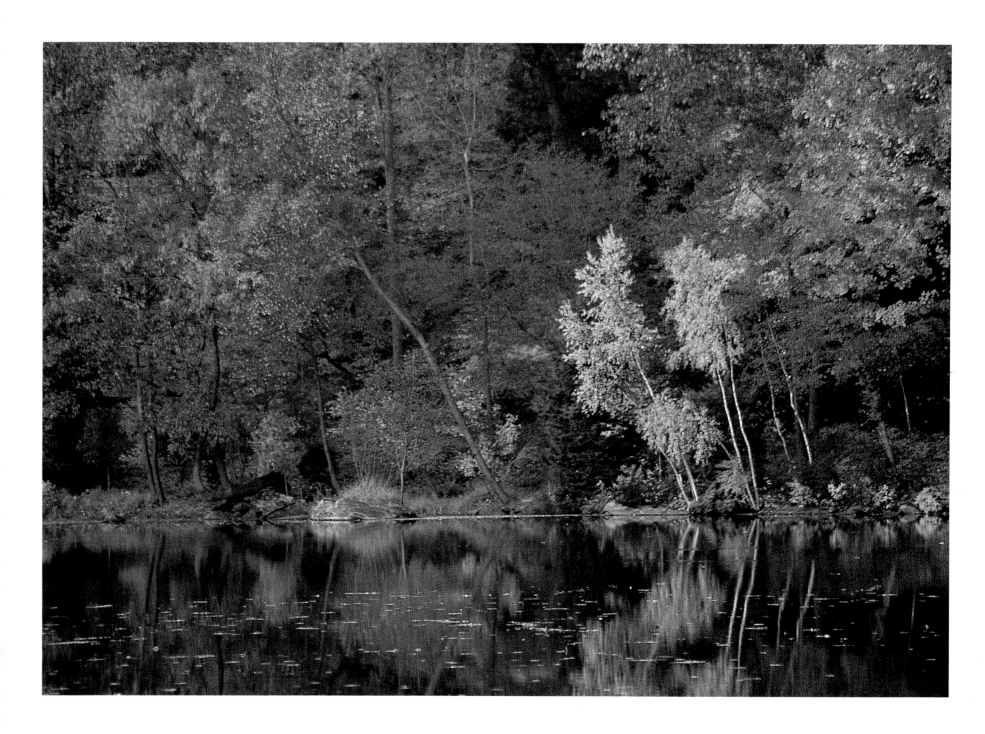

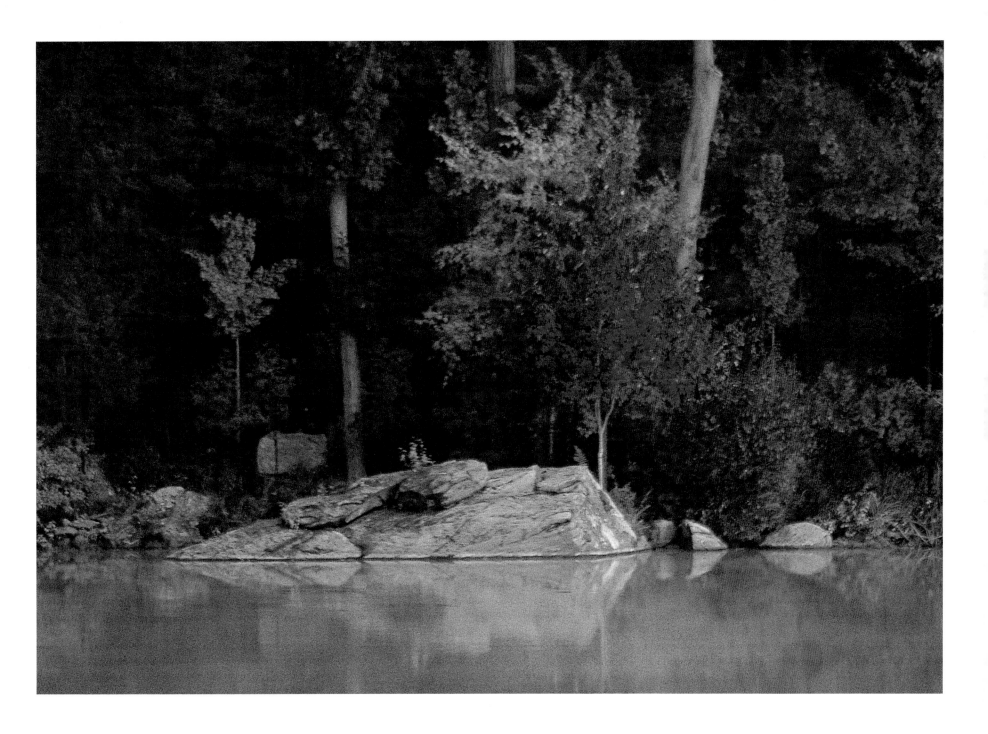

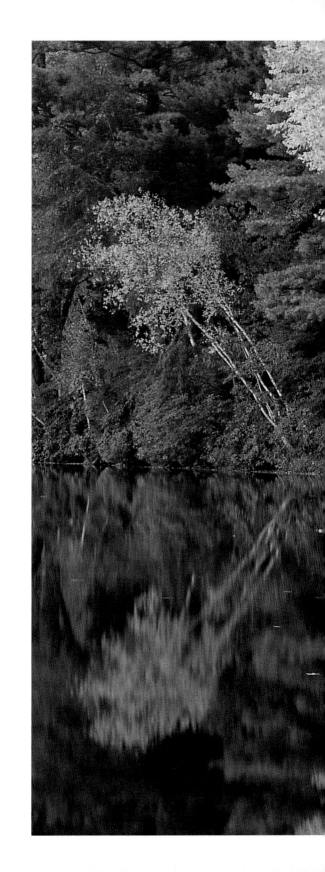

*RIGHT: Nature plants shrubs and small trees at the edge
of the woods, where sunlight slants under the canopy
of big trees. Here, shrubs in fall colors give the garden a
long-settled look, as do the birches leaning over the water.*

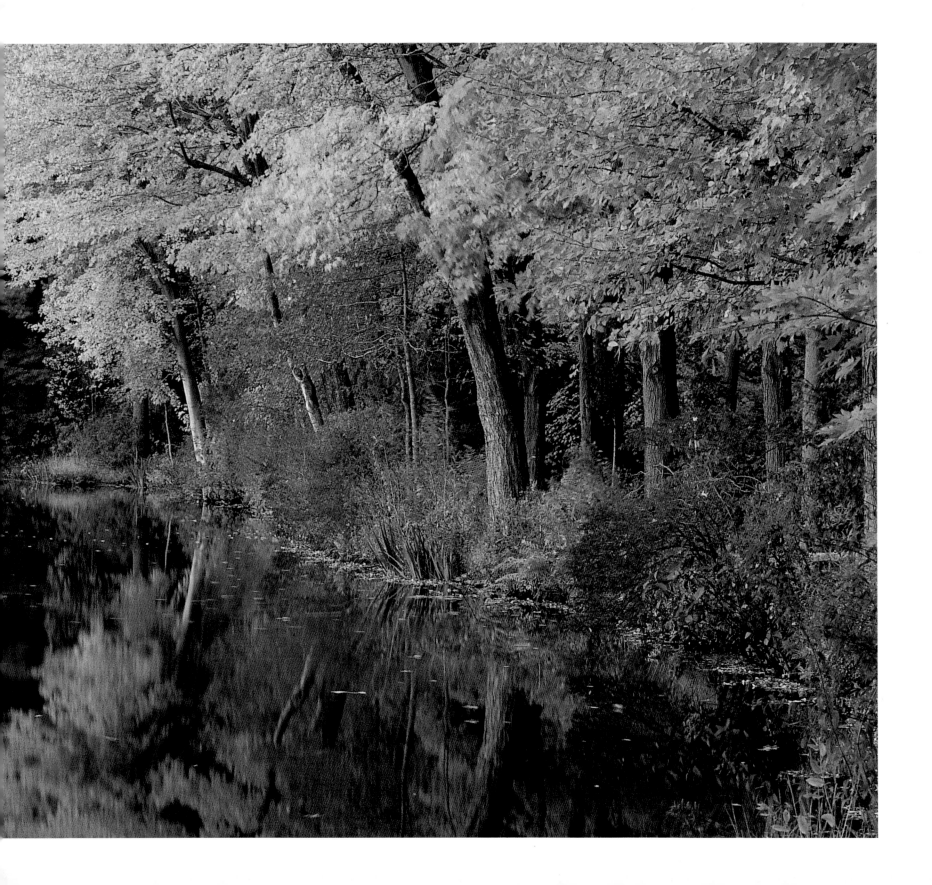

RIGHT: When a light snow sticks, it outlines the bones of a garden. Along the shoreline, dark trunks and branches stand out against a background of snow and the hazy light that it reflects, while a thin layer of snow traces the tops of twigs and rocks.

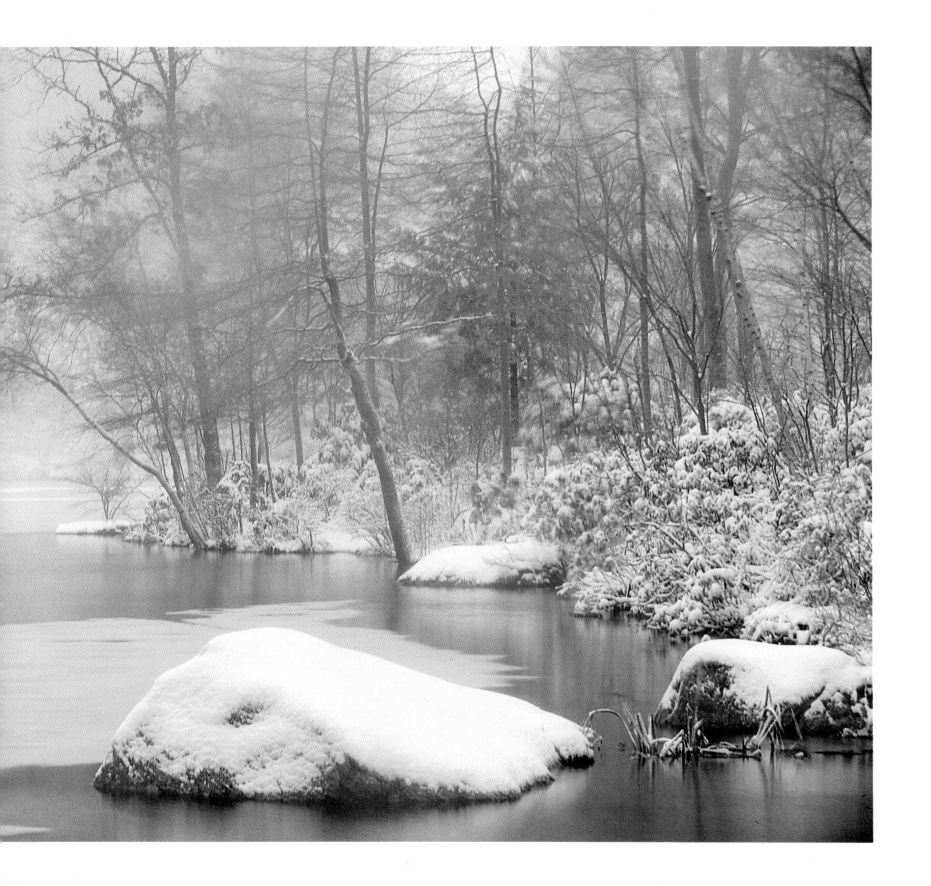

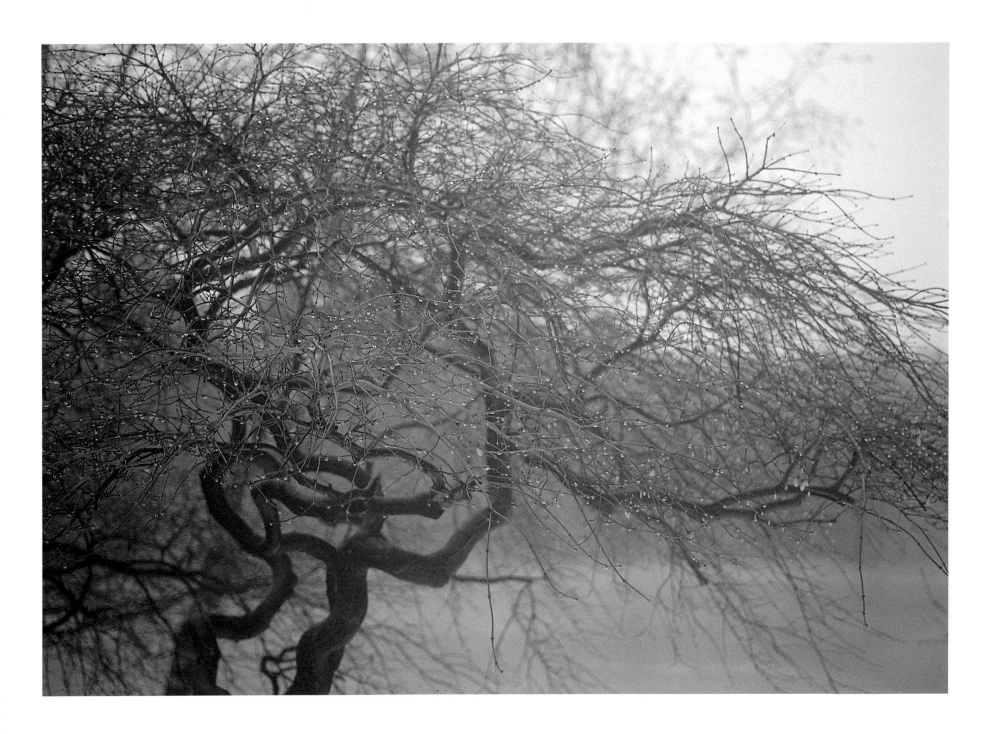

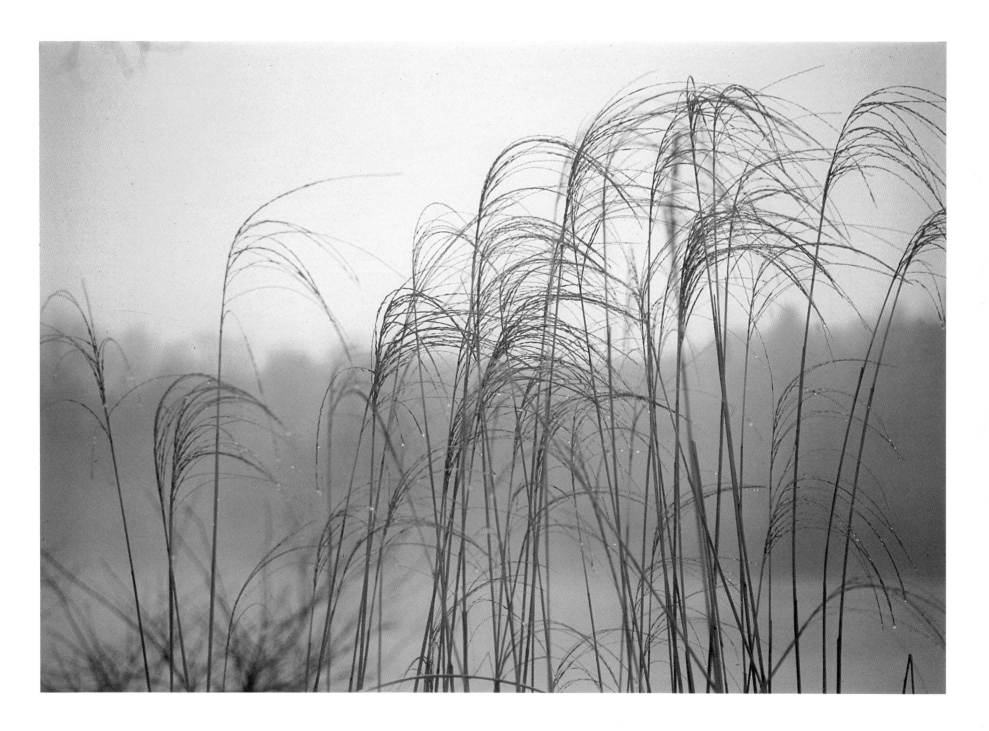

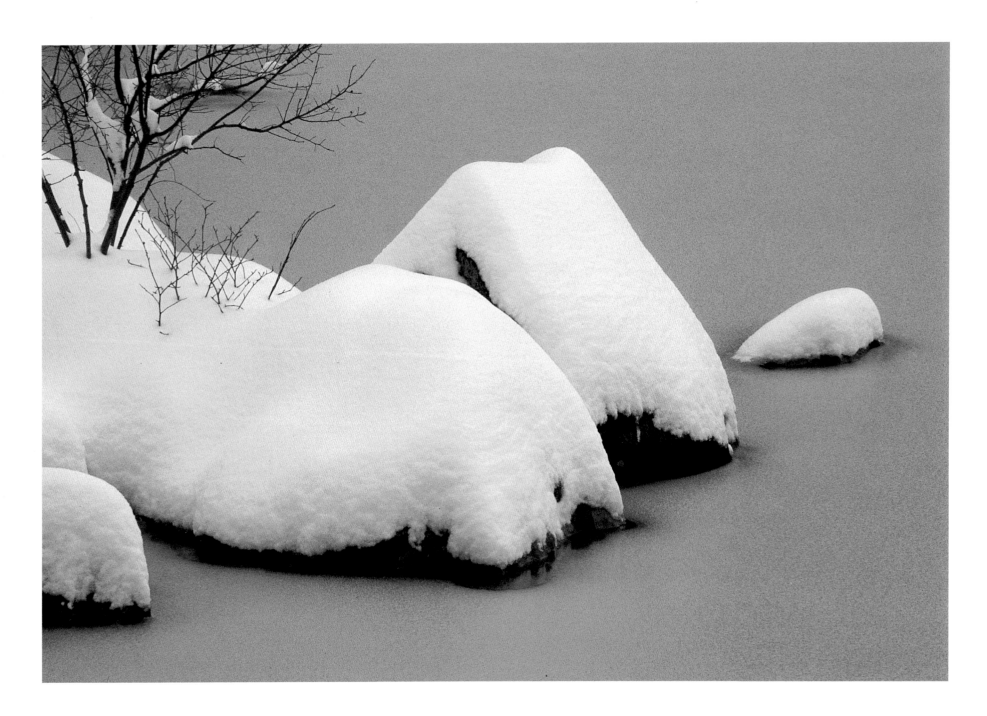

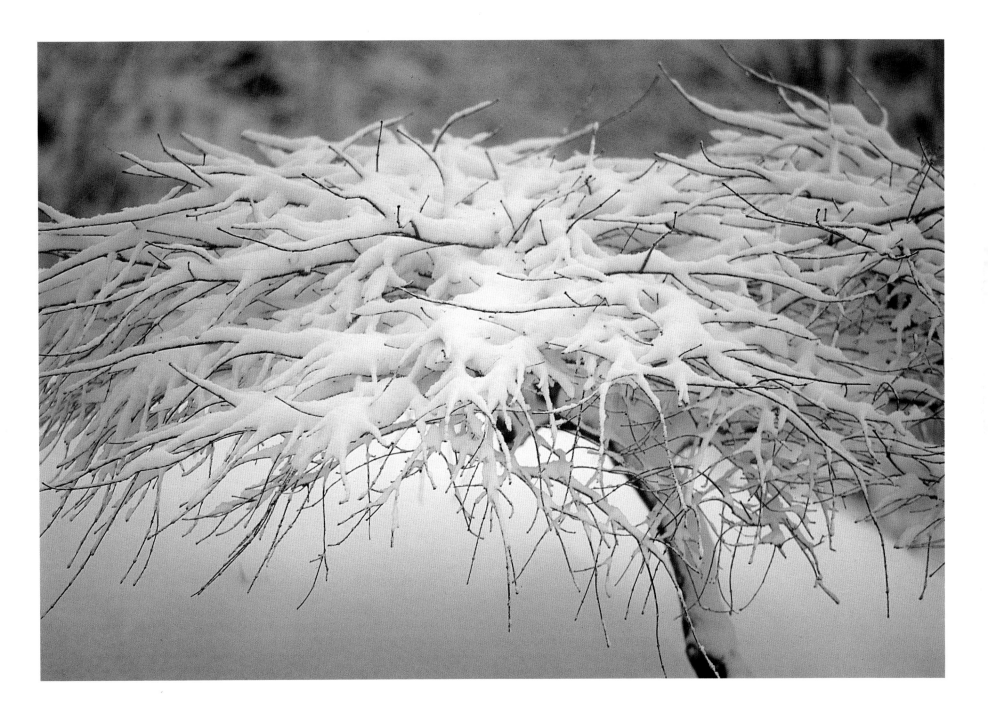

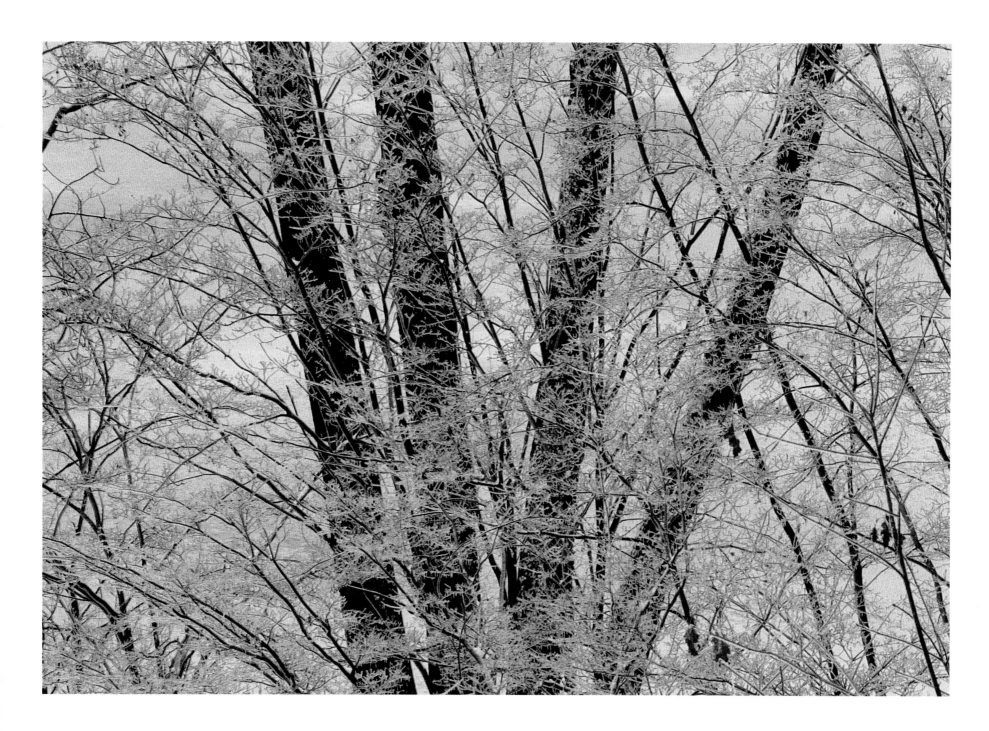

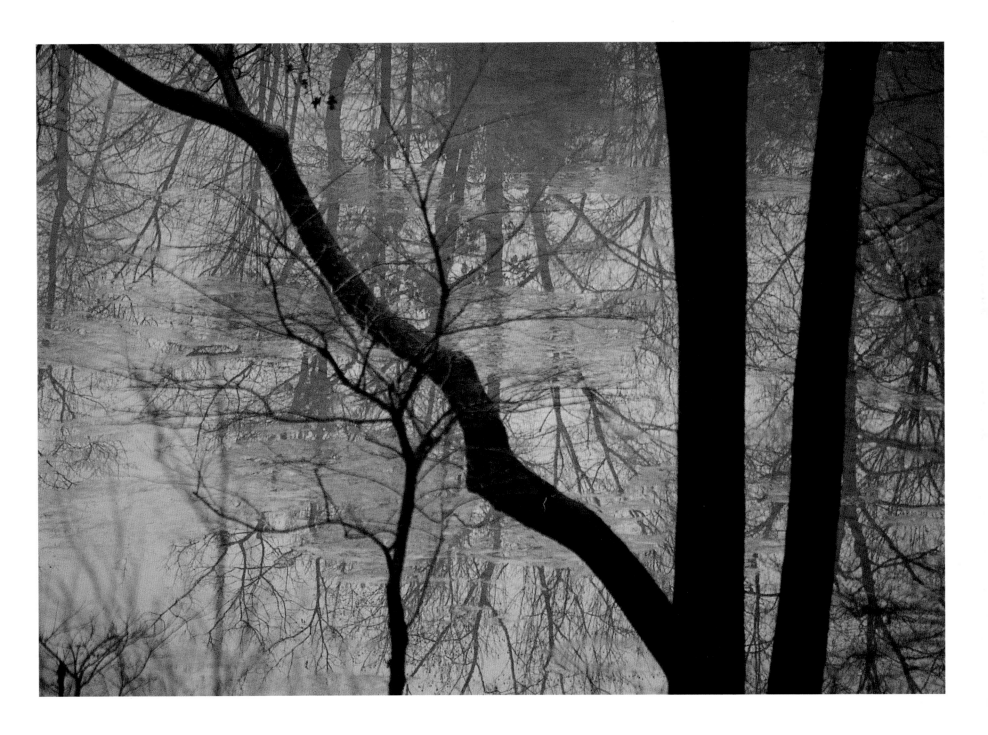

79

RIGHT: As the seasons change, so do the contrasts that enliven a garden. Slender but unbowed, the pale, dry seed stalks of grass stand as resolutely as the dark trunks of oaks.

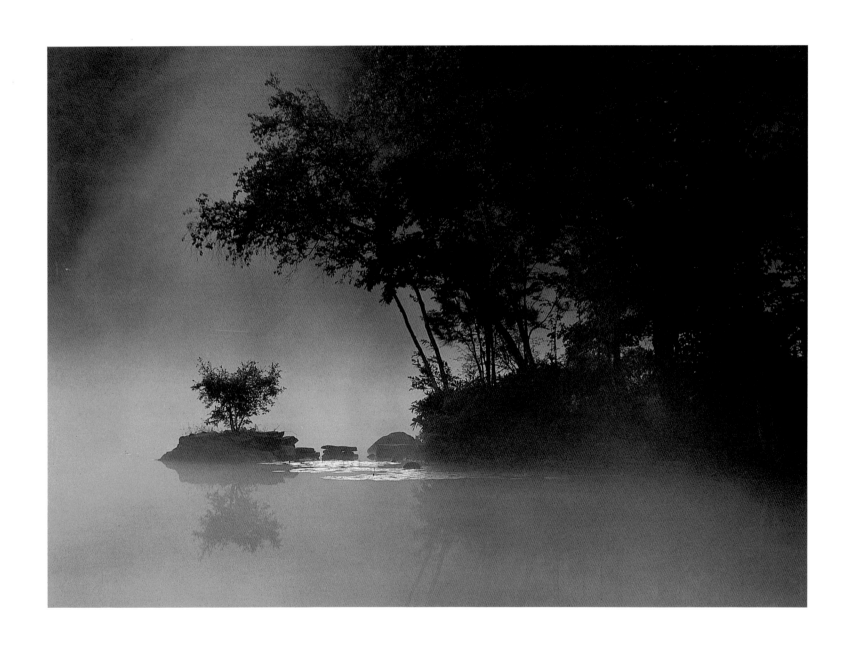

Ephemeral Moments

ALL GARDENS REWARD the meditative observer. They change from season to season, day to day, and second to second. Fleeting, evanescent, every moment in a garden has its own mix of light, atmosphere, weather and season. In the morning fog, the shoreline at Cobamong is an ink-wash drawing, all shades of gray and silhouettes, without shadows. In two minutes, the fog thins, the scene brightens, colors appear, shadows spread, the sun breaks out and rays of light shine through translucent petals and leaves. At midday, the high sun throws shadows straight down and the lake reflects blue sky. At twilight, a line of orange lights the western sky, casting alpenglow across the eastern lake shore, briefly coloring the woods with weak reds and oranges.

In all gardens, the seasons assure a succession of ephemeral moments. Crocuses send the tips of their grassy leaves pushing through the crust of a spring snow, like miners emerging from the earth after a long shift underground. In early spring, when the trees are still bare and the bright green tips of the skunk cabbage, looking like Belgian endive, are just emerging from the muck along the streams, an invisible chorus of frogs sings for the first time as night overtakes the sky. Then comes the incomparable moment in spring when the forest awakens and tender new leaves unfurl, covering the memory of bare hills with a healing green gauze. Then, for a few days, the new leaves of the oaks, still small and curled, are a subtle dusty rose.

In late spring, when the mornings are still cool, condensation strings spiderwebs with beads of dew. By mid-morning the dew vanishes, and the spiderwebs grow invisible again. They reappear in late fall, when spiders die and dust and flecks of debris cling to the abandoned, sagging cords.

OPPOSITE: Gardens offer an unending succession of unique passing moments, as the weather and the season alter plants, light and atmosphere. In fall, when cold air rests on the warm lake, mist hangs in the air.

In early summer, when the peony buds have grown round and swollen and are on the verge of opening, they lure busy flocks of ants with hidden pockets of nectar. Wasps pursue quizzical flights, following the twigs and leaves of an oak branch at a distance of an inch or two, hunting for caterpillars they will paralyze and carry back to their nests. Moss temporarily loses its green velvet look and grows a thin beard of minute wiry stems topped with spore capsules. After a wind-driven rain, sodden bark blackens the windward side of trees. The lichens that live on the bark drink up the water and revive, turning a vivid, contrasting green.

In fall, as the leaves begin to turn, they slowly lose their stores of water and the sound they make in the wind takes on a higher pitch. Over the lawn, frost lays a silver bedspread that vanishes with the first slanting touch of sunlight. For an hour, the lawn wears two colors — green in the sun, and silver in the shadows of trees. High and far away, geese honk in their flight.

The barren season has its moments. The seed stalks of a long-withered ornamental grass rise through a drift of snow, arching gracefully. A junco, with its gray back and white breast, flits from branch to branch, pecking at buds.

GARDENING TEACHES OBSERVATION and contemplation. Gardeners often work alone, absorbed in labor that busies the body but leaves the mind free to roam. And it is sensual. When you kneel on the ground in spring, the cold wet earth seeps through the fabric of your pants and touches your skin. When you sink a trowel and turn up the damp, black dirt, the smell of life rises to your nose. When you firm the soil around the roots of a new plant, your fingers feel the grit of sand and the slippery remnants of decaying leaves. When your back needs relief and you lift your head to stretch, you see with surprise the underside of a young maple — the branches that the leaves hide from view when you walk by and look down at the tree.

Sooner or later, most gardeners learn to seek the rewards of observation instead of waiting for them to call. A shrub may need pruning, but the gardener

OPPOSITE: A transient change in the atmosphere can signal the turning of a season. Though the full canopy of leaves belongs to high summer, the chill of fall wafts mist along the shoreline and high into the trees.

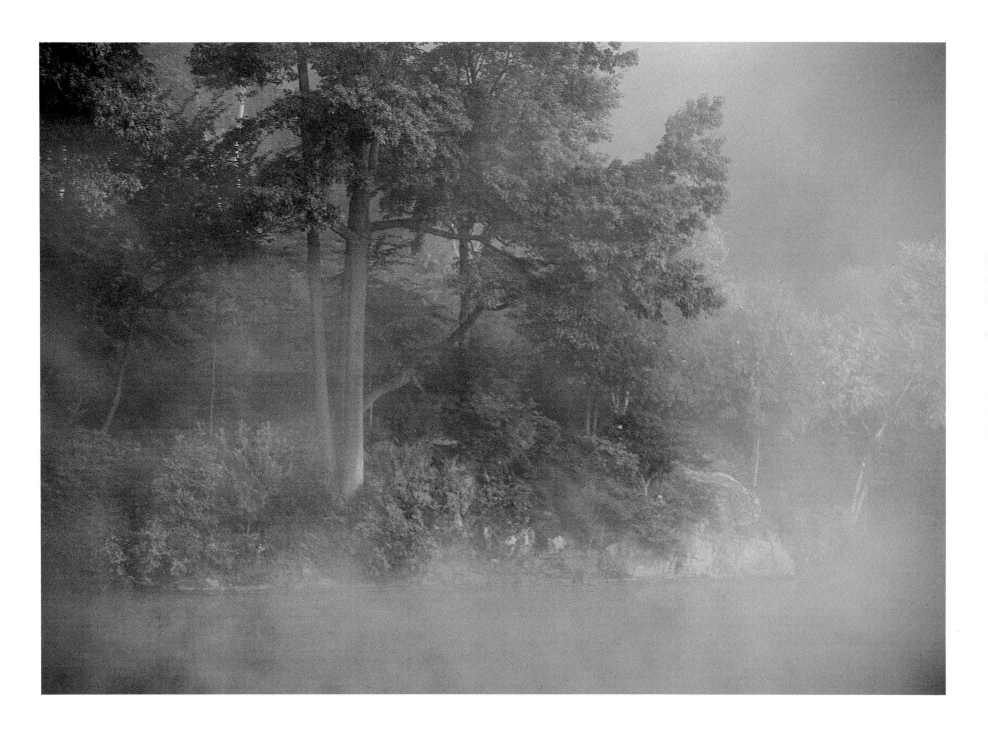

picks up the shears and heads for the garden as much in hope of seeing new marvels as in answer to the call of duty. Or the bulbs still in their packets may lie neglected on the ground while the gardener, lost in reverie, gazes at the seed head of a clematis, a ball of twisting, feathery plumes ready to fly and sail off on the wind.

Nierenberg has seen a lifetime of ephemeral moments at Cobamong, in every season and every part of the day from dawn to dusk. He knows which trees turn color first in the fall. He knows that the spreading Japanese maple in the clearing below the house displays its richest shade of orange for just one day. He sees the mist rise from the lake in fall, when the water is warmer than the air. In spring, he sees the tree pollen and duck feathers that float on the water, pushed to shore in swirls by the wind.

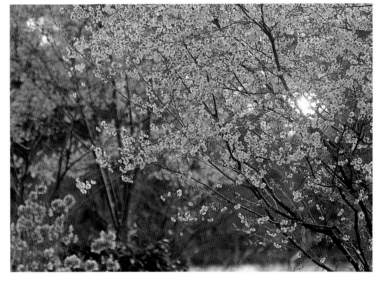

In great gardens, the gardener learns from the pleasures of the moment. The lessons are often practical. When a beam of sunlight falls on the blades of an iris, so they glow green, the gardener who has paused while pruning and chanced to look up will realize that another iris, placed at the turn in the path just ahead, will catch the setting sun the same way, and so will a peony or a fern in a similar place. But the lessons are spiritual, too. You see nothing until you learn to observe. The world of nature is rich and mysterious, always deeper, infinitely rewarding for anyone who stops to look. Moving shrubs and trees, prying boulders into place for steps, dividing hostas and daylilies, for thirty-six years Nierenberg has absorbed the lesson of the moment. His photographs make time pause.

ABOVE: In a gardener's year, the peak of cherry blossoms announces the time of year as surely as the angle of the sun, the temperature of the air or the frogs piping at night on the shore of the lake.

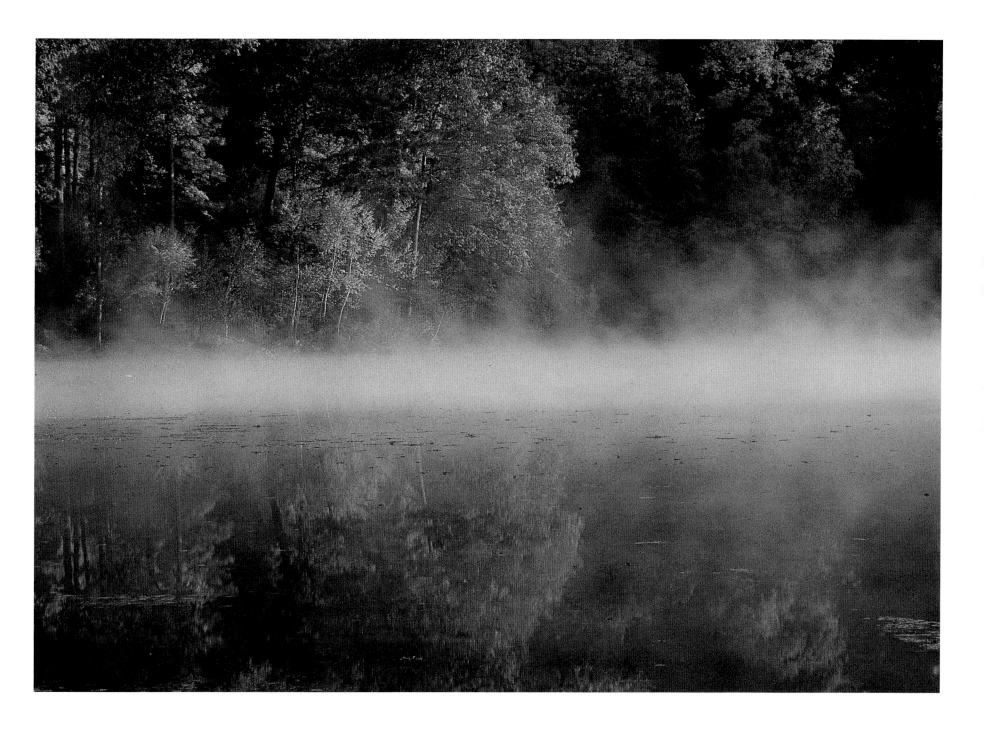

Stray feathers and a sheet of oak pollen paint swirls on the surface of the lake,
marking the brief moment in spring when trees and ducks prepare for a new season.

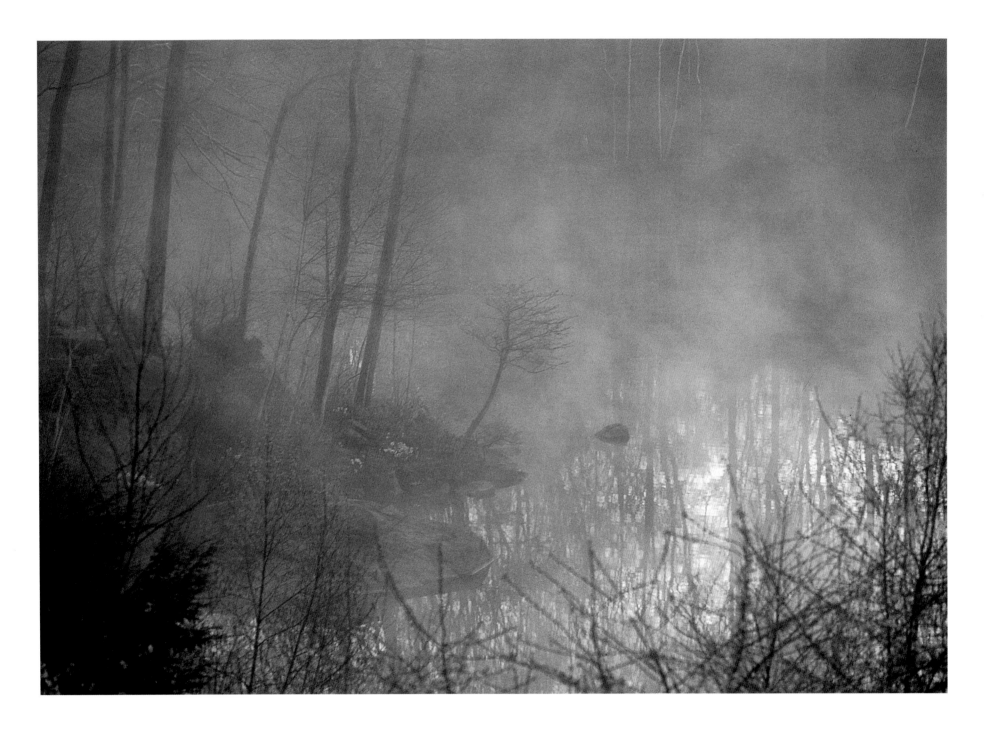

89

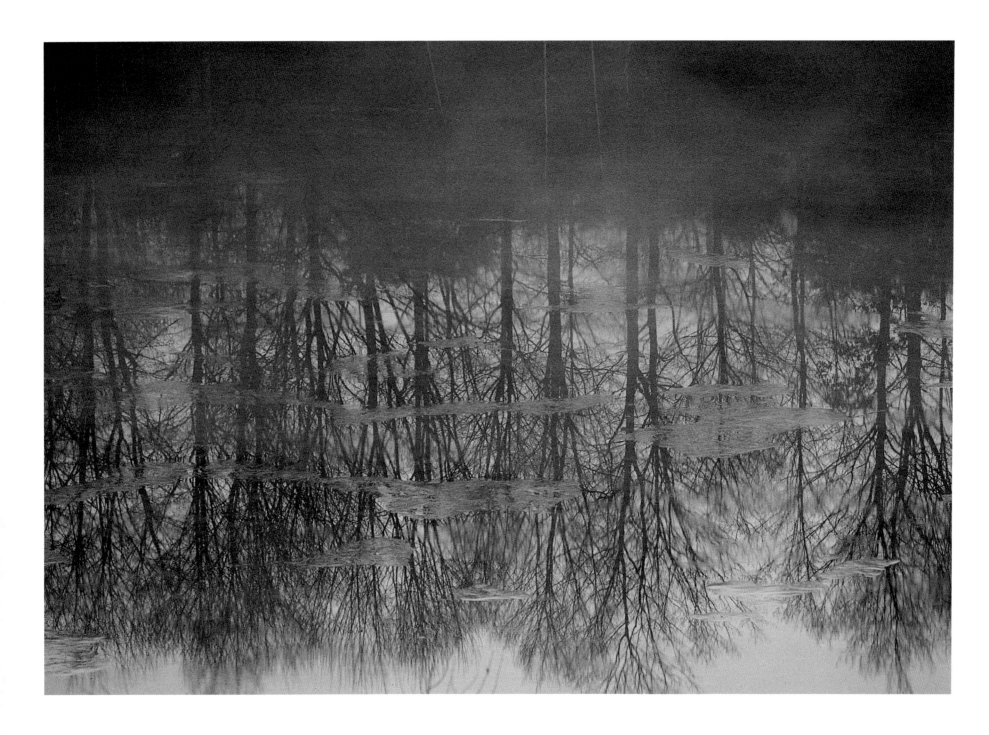

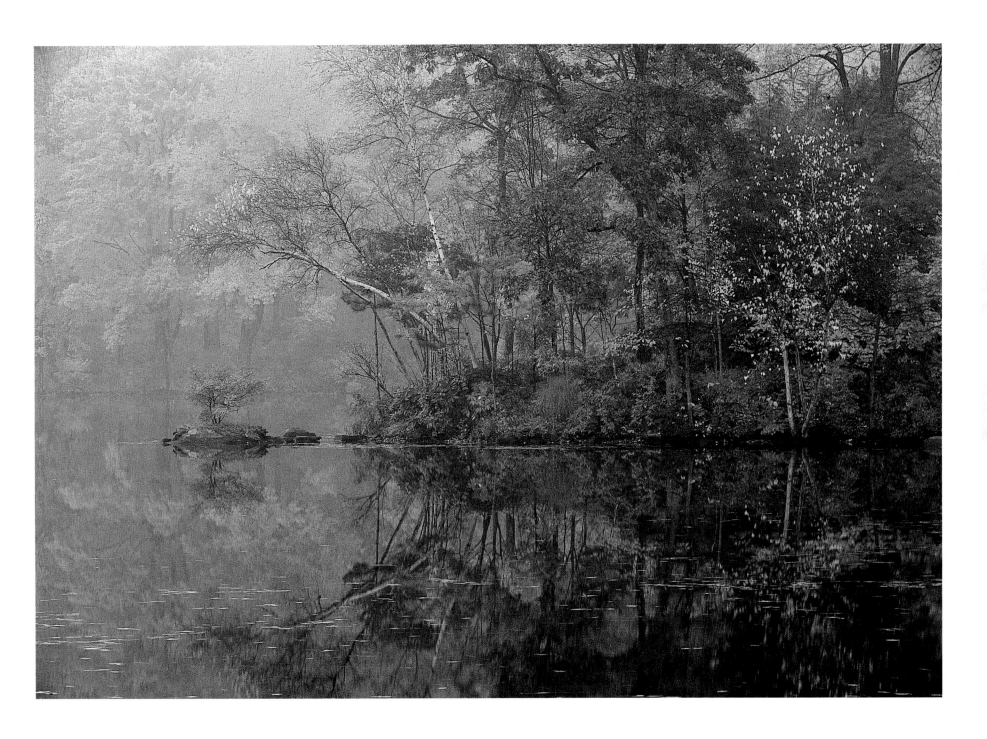

91

RIGHT: *Early morning, before the low sun can warm the air, is an enchanted time in the garden. On the shore, dew clings to the blades of grass and the petals of flowers. On a lake, vapor rises from the warm water and fleetingly condenses to mist in the cool air above.*

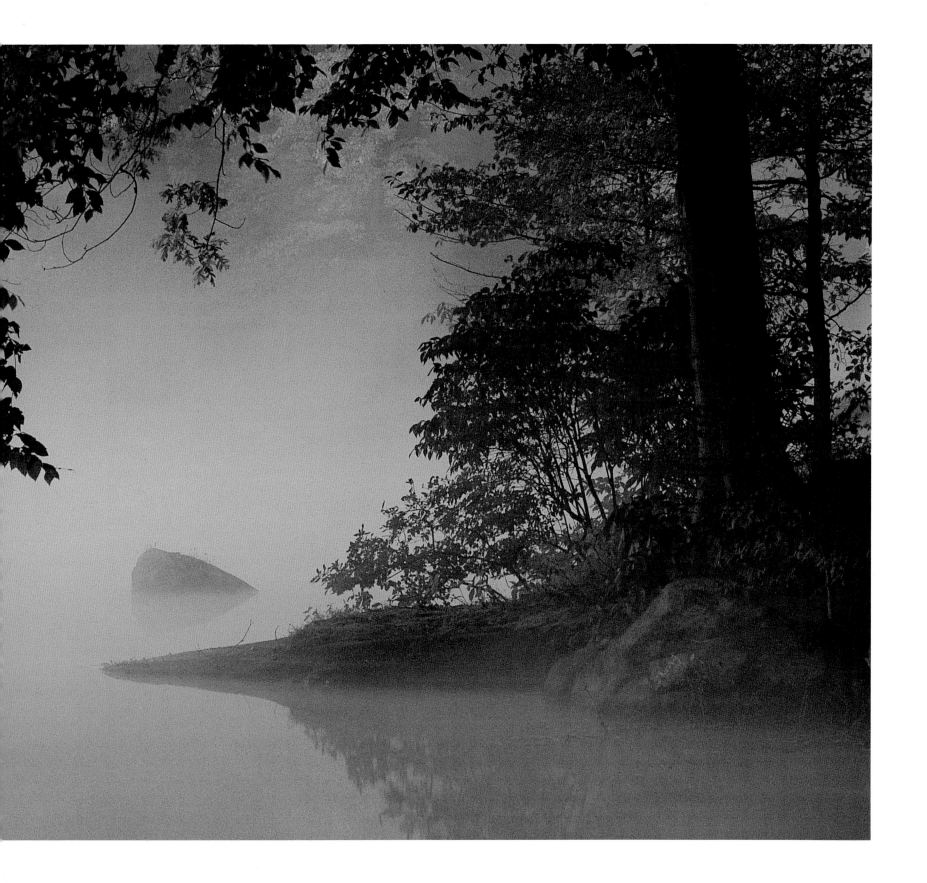

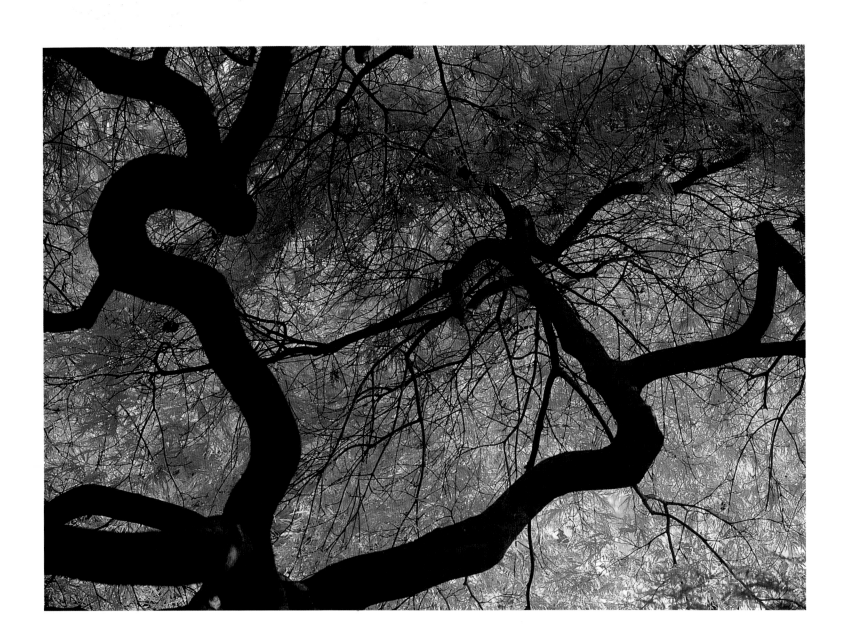

The Lifelong Garden

HAPPILY, GARDENING has no end. For a gardener lucky enough to live in one place for thirty-six years, when every day of work remains in place, the garden holds a treasure of memories. Old gardens reflect the character of their makers with surprising intimacy. They also take on their own character and influence the gardener. Call it a collaboration.

Though Cobamong has a natural look, the garden is really an artifice, shaped by uncountable hours of work. Every day that Nierenberg goes to the garden, he weeds, plants, rearranges, culls, prunes. He carries two tools: pruning shears and marking tape. When he sees a branch trespassing on the path, or a shrub whose yellowing leaves may indicate a dearth of fertilizer, he ties a length of tape around the plant, an easier reminder than taking notes.

Gardens must be renewed. Since his first years at Cobamong, Nierenberg has drawn his garden philosophy from this passage by Vita Sackville-West: "Gardening is largely a question of mixing one sort of plant with another sort of plant, and of seeing how they marry happily together; and if you see that they don't marry happily, then you must hoist one of them out; and be quite ruthless about it.

"That is the only way to garden, and that is why I advise every gardener to go round his garden now and make notes of what he thinks he ought to remove and of what he wants to plant later on. The true gardener must be brutal and imaginative...."

When a tree grows too large for its spot, Nierenberg takes it out. No matter that it may have reached a size that many gardeners would envy: no matter that the labor of uprooting it is considerable. The tree may be shredded and recycled, or Nierenberg may tuck it into a new home, often a crevice between boulders that is so narrow the tree looks as though it

OPPOSITE: When a gardener is lucky enough to live and garden in one place for decades, no work is lost. The twisting branches of a Japanese maple recall pruning cuts made years ago and every cut made since.

must have grown there from a seed. Surely no one could transplant a fifteen-foot-tall tree into a two-foot-wide crevice between boulders the size of small hippos. The only clue that gardeners have passed this way is a ring of big rocks around the tree, keeping roots still when the tree sways in the wind.

Like books in a library, every plant that Nierenberg has brought to Cobamong holds a story. They recall visits to nurseries, friendships, favorite plant books, recommendations from friends, meetings with fellow gardeners. When Cobamong was new, Nierenberg bought a Japanese threadleaf maple at an estate on Long Island. The tree was almost one hundred years old then, and overgrown. Nierenberg planted it at the start of the path to the lake, where visitors pass under one side of its canopy. He has pruned the tree every year for thirty years. Its branches rise in graceful curves to an arching canopy of leaves and twigs. Underneath, the tree is an umbrella. From a distance, it is a spreading dome. Every snip of the shears, every stroke of the saw, every choice Nierenberg has made is preserved in the seemingly spontaneous shape of the tree.

Nearly all the work that goes into making a garden endures to reward the gardener. The daffodils bloom every spring, the dogwood trees turn gold every fall, the curve of the lawn yields grace year after year. And what endures also measures achievement. Most people long to leave their mark. Lifelong gardeners not only make their mark, they know they've made it.

Gardening is like raising children. The work is hard, but from the start the rewards outweigh the labor. The baby shrub planted today repays the gardener tomorrow with swelling buds and emerging leaves. The waist-high tree planted today in twenty years becomes a sheltering canopy. When a gardener swings a mattock all day long, sweating, winded, dirty, twenty new feet of path emerge and endure. Every day in the garden, a dream comes closer to its reality.

Lifelong gardens and health are mysteriously linked. Perhaps a lifelong garden can only take root in the sort of stable, satisfying life that also sustains

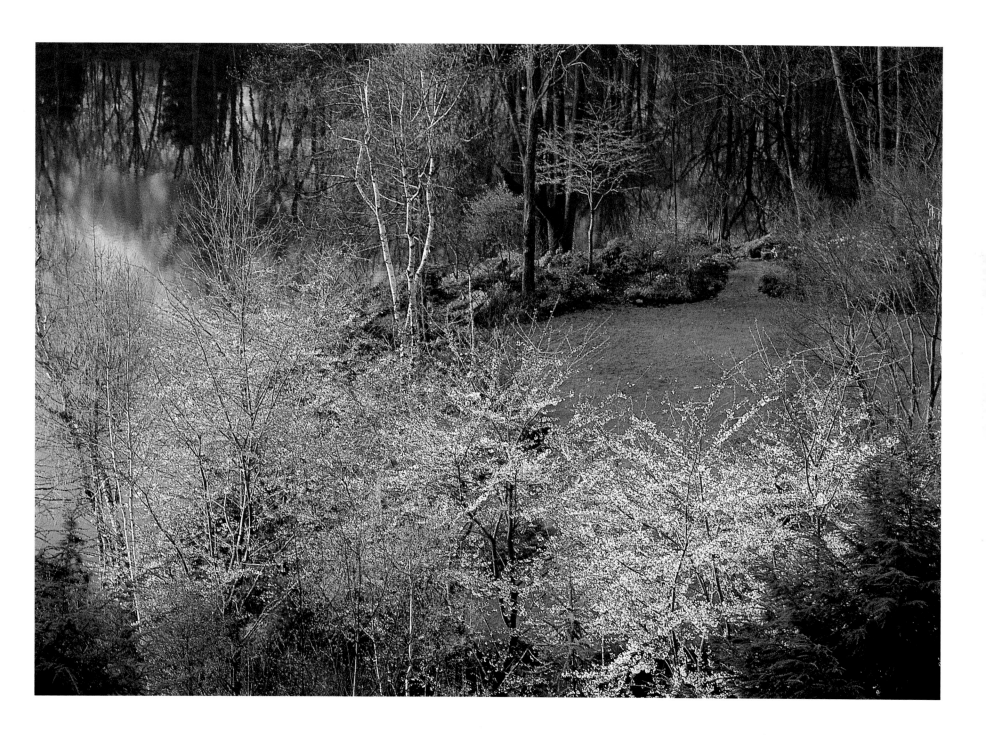

health. Or could it be that a lifelong garden reflects the irrepressible energy of an inherently healthy person? We can't know.

Cobamong took shape when Nierenberg was young, and it remains a young man's garden. To make a full circuit of the paths demands a strenuous hike. Even the start of the garden is arduous. Steep, twisting stone steps descend from the house to the lake. The treads are granite chunks, broken from bedrock by the glacier that came down from the north ten thousand years ago like an enormous bull-dozer. From amongst the rubble, Nierenberg chose stones with reasonably flat planes, then stacked them, digging pockets in the slope so that part of each stone rests on the step below and part rests on earth. The treads vary in height. They offer frac-tured planes and uneven edges that demand care. When dew or rain has made the moss and lichen slick, visitors have to feel their way before they shift weight from one foot to the other.

THIRTY-SIX YEARS HAVE PASSED since Nieren-berg began to make his garden. He is no longer a young man, but Cobamong sustains his passion. On a winter day with wet, treacherous snow on the paths, Nierenberg and I circled the lake in foot-numbing cold. He led the way, his shoes following the familiar path, his hand occasionally reaching for a branch to steady himself. We passed a grove of thirty-five-foot hemlocks, which he bought as six-inch seed-lings from a midwestern nursery long ago. With our arms out-stretched for balance, we crossed a narrow plank over the spillway of the dam. We stopped often to talk about trees that had just been moved, as well as his plans for others that would soon be moved.

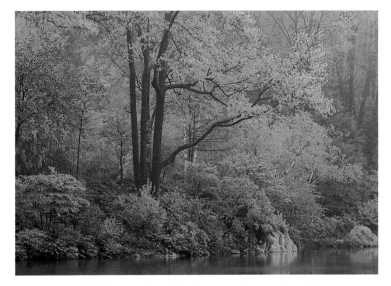

ABOVE: In a lifelong garden, the plants reach maturity with the gardener. Shrubs and trees that started life as twigs now paint the shoreline with the tender greens of early spring.

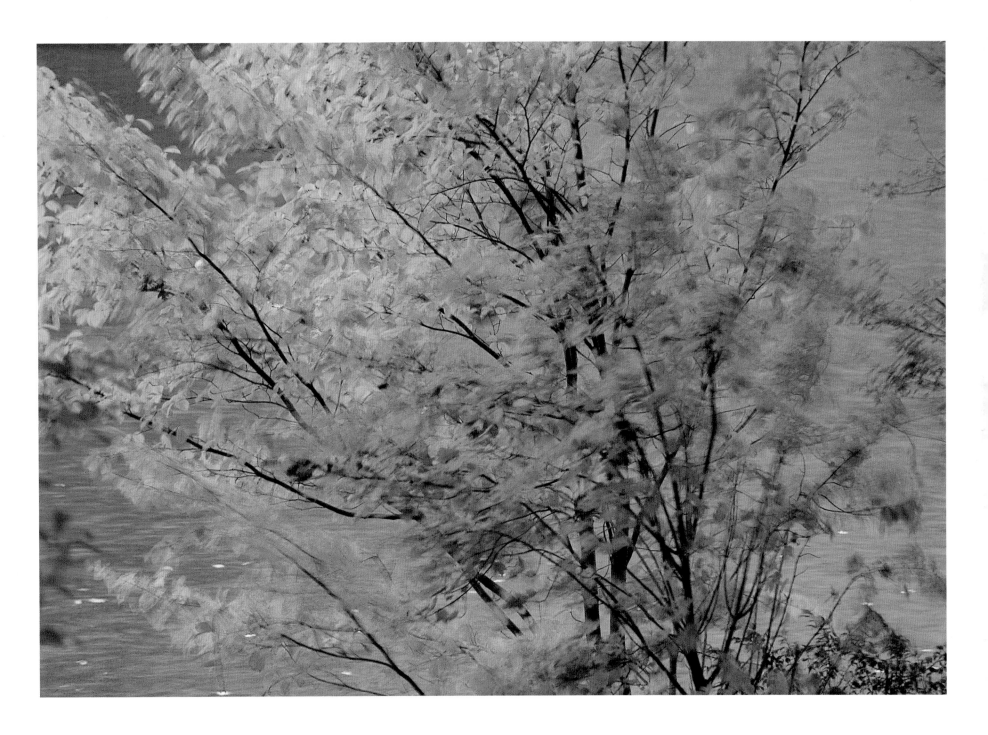

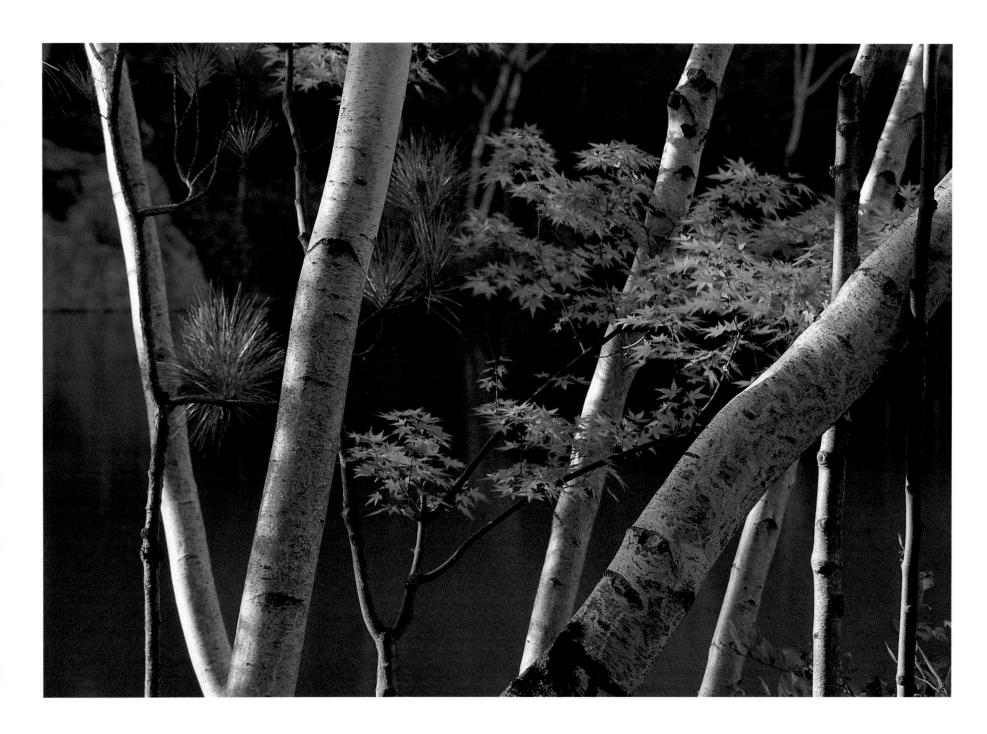

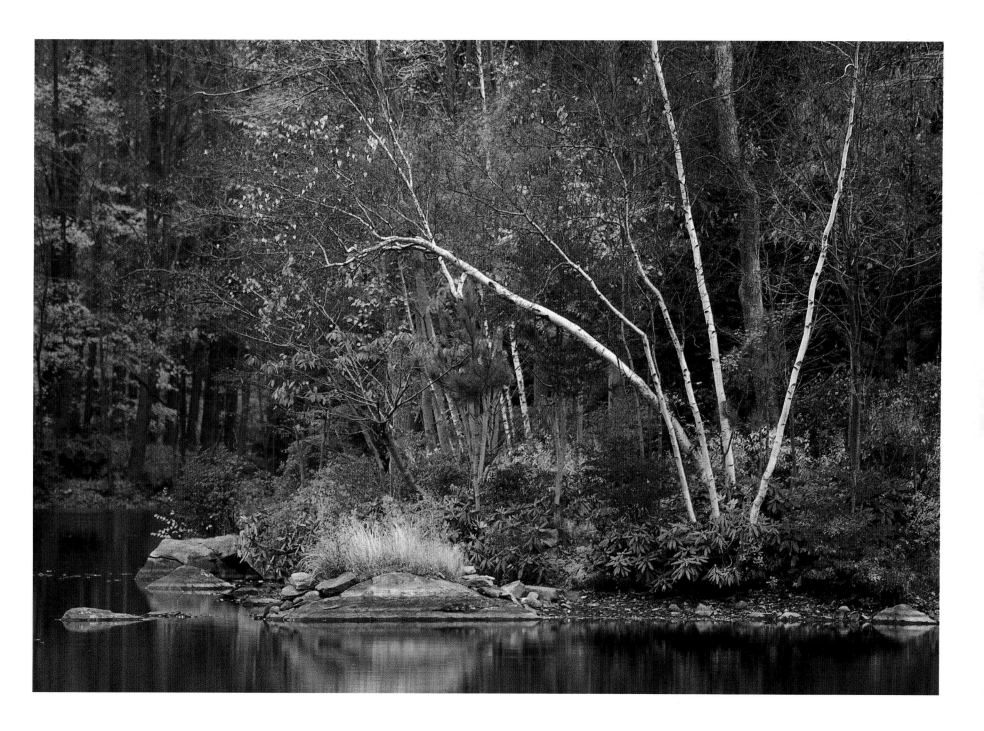

RIGHT: A lifelong garden is a collaboration: the gardener starts the design and nature supplies growth and details. Nestled in the deep shade between the buttresses of two oaks, a hosta sends up its flower stalks as the gardener expected, while nature softens the oak bark with moss.

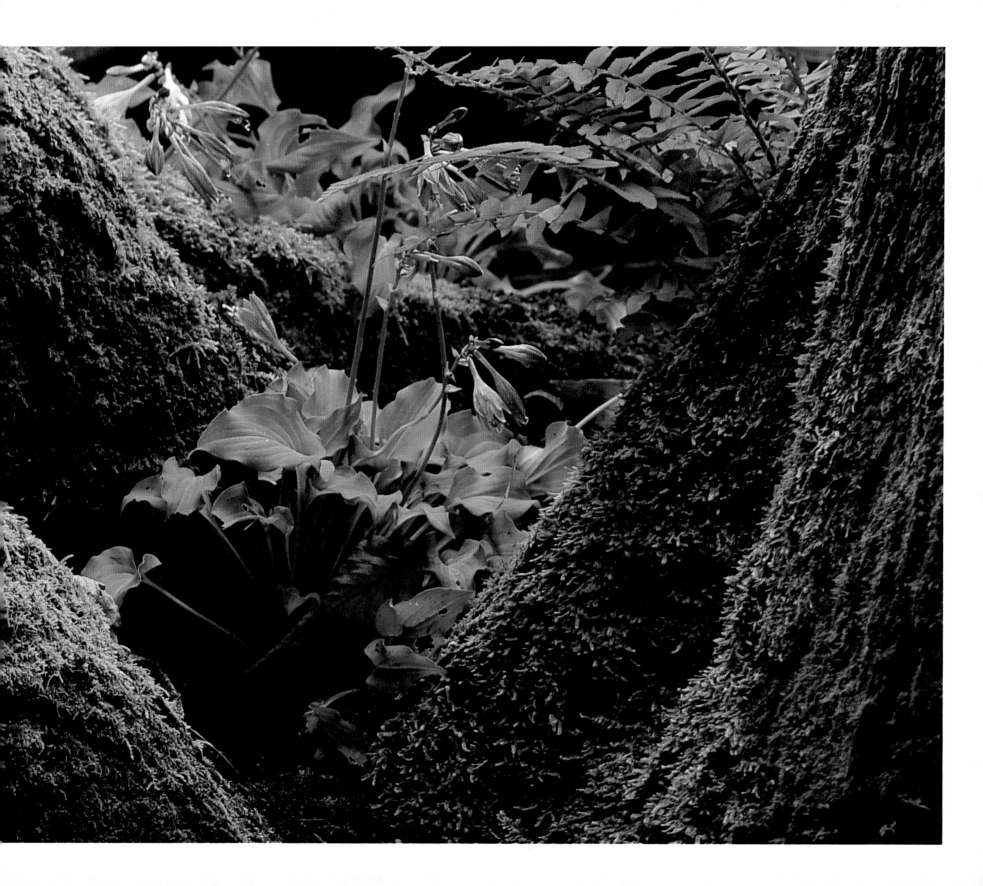

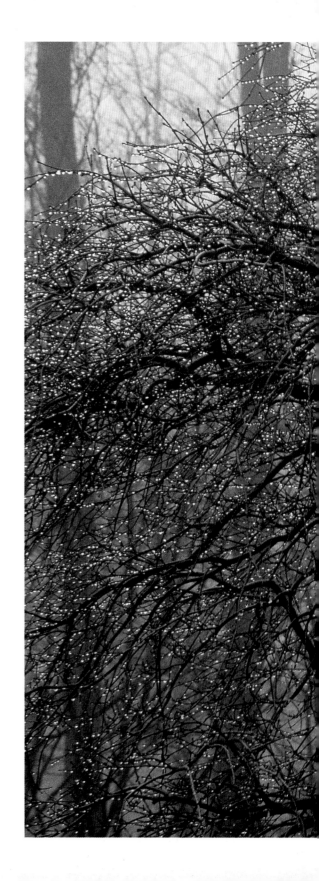

RIGHT: A lifelong garden preserves and recalls the gardener's labors. Sapling trees grow up and join the canopy of mature oaks, and the twisting branches of the Japanese maple in winter trace years of judicious pruning.

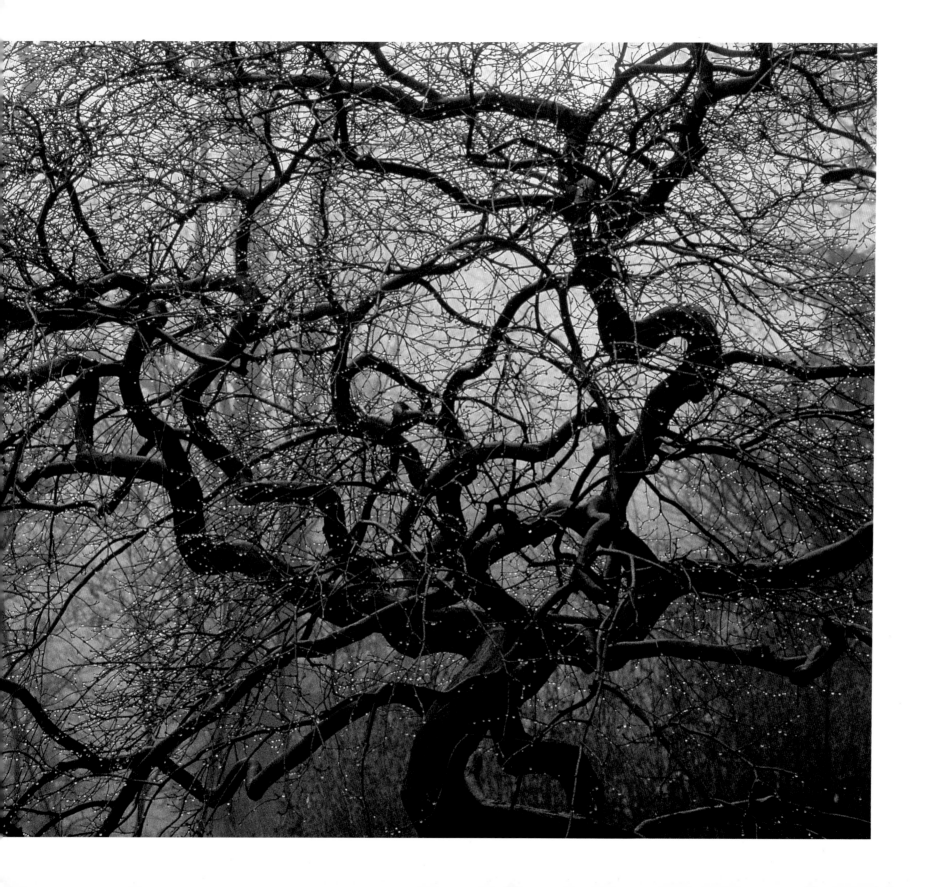

Principles of Garden Design
Ten Lessons from The Beckoning Path

FROM COBAMONG, a lakeside natural garden on a grand scale in the Northeastern United States, gardeners in any region can draw lessons about garden design. The principles that shape the landscape at Cobamong can be applied to any property. Here are ten of them, guidelines to help you create a garden that honors its surroundings; a garden that incorporates paths as an essential element, leading the eyes and inviting exploration; a garden in which mystery and surprise complement each other; a garden made rich by refuges and overlooks, which can be designed to turn any terrain to advantage. The lessons from Cobamong illustrate how to mingle plantings and clearings—whether lawn, meadow, or pond; how to give a garden drama by planting in groups; the principles of layering, both horizontal and vertical; and how to control the variety of your plantings. Planning for year-round interest and sequential blooming are of special interest to those living in regions with defined seasons. Finally, Cobamong shows how flexibility and constant analysis can become essential tools for the gardener.

Lesson 1: Respect Your Assets and Surroundings

The first step in garden design is to look outward. Observe what surrounds your property. What grows naturally in your area? Is it prairie? Is it Eastern hardwood forest? Is it summer-dormant grasses and drought-tolerant trees, as in Northern California? Observe the main features of your property. Do you have the shelter of full-grown trees? If so, then use them in your design. (If you planted young trees today, they would not reach maturity during your lifetime.) Are you able to "borrow" the privacy of an

adjacent nature conservancy or benefit from the boundary of a river? Does the topography of your property vary? Do you have a view?

Next, assess the character of your neighborhood. When were the houses built, and in what style? How close together are they? Is the neighborhood well established, with venerable trees, or new and bare, exposed to the sun? As you make your garden, take into account the nature of its environment.

The style of your garden should complement the style of your house. If you live in a bungalow, you may want an informal garden, overflowing and rich with color and texture. If you live in a ranch house in a suburban neighborhood surrounded by lawns, start your garden at the foundation, with low, graceful shrubs. Brighten the foundation by setting

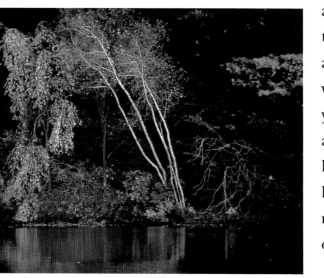

perennials in front of the shrubs; in front of the perennials set low ground covers. Bring the flower bed farther into the lawn than your neighbors have done, but respect the character of the neighborhood, and refrain from converting the yard into a welter of colors and textures. If you live in a stone or stucco house with a formal character, your garden should have a more formal feel. Perhaps add a courtyard with low, sheared hedges surrounding an herb garden or beds of bulbs.

Distinguish between the public face of your property and the private regions. Where your front yard faces the street and neighbors, strike a balance between the view toward the house and the view from the house outward. Please yourself, but consider your neighbors, too. In your back yard, you can create a sanctuary with pri-

LESSON 1: Whether bordered by water or a neighboring yard,
the perimeter of a property is an opportunity for creative planting.

vacy on three sides. While you can screen the property from view with fences, walls, terraces, and buildings, consider perimeter plantings too. Evergreens planted in a straight row soon grow leggy, opening unwelcome space beneath their boughs. Planting a border of varying height and depth assures seclusion. In the privacy provided by an enclosure, you can design the garden in any fashion you choose.

Finally, suit your plantings both to the site and to the climate. If your property bakes in full sun, grow sun-loving plants such as lilacs, daylilies and peonies. If your property is largely shaded by mature trees, then focus on forest-growing plants such as viburnums, ferns, and Solomon's seal, as well as spring ephemerals that appear early in the year and bloom before the trees are clothed with leaves. If you live in a dry climate, or your garden has soil that drains speedily, you will want to grow plants that tolerate drought—perennials such as rudbeckia and coreopsis—and put in trees such as oaks and locusts. If your climate is wet, or your soil is slow to drain and stays moist almost constantly, then plant trees such as sweet gums and maples, and grow plants that thrive on wetness, such as astilbes and irises. By matching plants to your growing conditions, and keeping your garden in character with its region, you can create a harmonious garden and spare yourself the onerous maintenance that can make gardening seem a chore.

Lesson 2: Create Beckoning Paths

Paths are essential to garden design. They divide a property, then thread the broken pieces together. They offer a route for the eye to travel through the garden, surveying and assembling each section into a coherent picture. Paths also provide the drama, mystery, and surprise that enliven a garden stroll. They can hasten you along or slow you down. They can bring you to a stop. They can lead you to an unexpected vista, or detour you past a bench that invites you to pause before you push on.

When you lay out garden paths, keep several principles in mind. First, decide where your paths

should lead. Generally, you see the garden most often from windows in your house, from the front of the property across the lawn, or from the backyard. Stand in each of these spots, and ask where your eye goes first. Make the answer the destination of your path. If there is more than one focal point, decide if you will make separate paths to each, or branches from a main path, or perhaps two main paths.

Now ask yourself which destinations are solely practical and which are for pleasure. Then design the paths accordingly. For example, if you need a path that leads behind the garage to the compost pile, make it direct and solid, so you can get to your destination speedily and with solid footing when you are carrying bags of leaves or guiding a wheel-barrow-load of prunings and yard debris. On the other hand, if your destination is a bench at the back of a property, a fa-

vorite sitting spot where you look across the garden toward the house, then send the path on a meandering route that slows the approach to your destination, so you can prolong the pleasant anticipation of your arrival.

Second, vary the rhythms of your paths. In places, make them wide enough for two people to stroll abreast, then narrow them so that only one person can proceed. Give paths gentle, sweeping curves where you want to look ahead and enjoy the site of a wide swath of the garden; tighten the curves to sharp turns where you want the path to disappear from view, or where visitors should slow their pace and focus their gaze down to a strategically planted spring jewel such as bloodroot, whose white daisylike flowers rise only a few inches above the ground. Change levels: send the path up a slope and turn it around a rise,

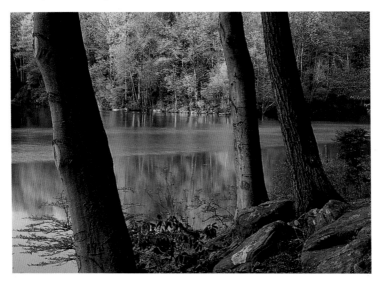

LESSON 2: A path can skirt a lake, bisect an herb garden or weave through a bed of perennials.

then send it down the other side. Interrupt the path on a slight slope with steps instead of sending the path ahead unbroken. When making steps, keep the first stretch level, then construct several steps up and run another level stretch. Japanese gardens often incorporate a bridge over a small pond, constructed in levels to bring the walker to a brief, attentive halt.

Finally, create paths of materials that suit your garden. Cobamong paths are dirt, carpeted with fallen leaves and pine needles, and often edged with moss. Steps are made of granite stones and boulders fractured by the great glacier that ground across the Northeast ten thousand years ago. If your garden is formal, with sheared hedges, a neatly edged lawn, and ornamental beds laid out in straight lines, then make paths of materials that can be laid with precision, such as bricks, concrete pavers, and cut flagstones. But if your garden is informal, with curving beds and plants that spill on to the lawn, then make your paths of materials that are less even underfoot and pleasantly variable, such as pine needles, shredded bark, wood chips, gravel, and natural flagstones.

Lesson 3: Provide Refuges and Overlooks

Cobamong offers a valuable lesson about garden refuges. Surrounded by hills and isolated even from the sound of traffic, it feels like a separate world. When you walk the path along the shoreline and leave the house far behind, the sight of the stone bench that backs up against a shed-sized boulder is a welcome one. The lure of the bench is irresistible: you sit with your back against the boulder, shrubs on either side, relaxed and sheltered from the wind. A calm settles over you. Here, nothing can catch you by surprise.

In the garden there are several ways to create refuges. Try making an alcove of shrubs and place a bench in it; set a chair under an arbor where roses or grapevines climb. At the end of the garden, hidden from the house, let a path open to a patch of lawn surrounded by perennials and shrubs, and at the far side of the lawn place a lounge chair or a log bench.

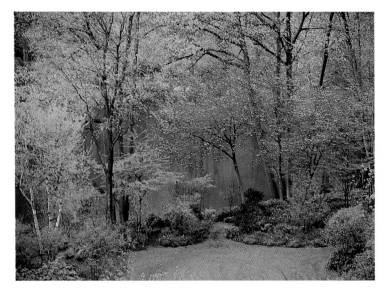

To be effective, a refuge must at least seem to be enclosed on three sides; the only entrance should be from the fourth side. A refuge feels most secure when the opening to it looks across a long vista, so that approaching visitors come into view long before they are near.

Overlooks, like refuges, soothe an atavistic need to know what surrounds us, to know where we are. From a vantage point we can orient ourselves in the garden, see what lies ahead, and recall where we have been. How you create an overlook depends on your property. On sloping land, guide the path to the highest point, where there is a view that is open and unobstructed. On a flat property, an overlook may simply be a wide spot in the path where the plantings on all sides are low enough to offer a panoramic view. Or, an overlook may be a garden structure—a gazebo, or a freestanding deck three steps up from ground level. Though barely higher than the rest of the yard, a platform offers the full appeal of an overlook. The most rewarding sites for overlooks include a surprise—a lone, spectacular shrub, or a log-hewn bench.

Lesson 4: Mingle Clearings and Plantings

If you have ever walked through a long stretch of forest in summer, lost in greenery, you understand the sense of relief that clearings provide. In a garden, they add balance, offering relief for the eye from the colors and textures of plants. They give shadows and light to the garden and bring down the blue sky to complement the garden's various greens. Clearings introduce an open, public feeling that makes the rest

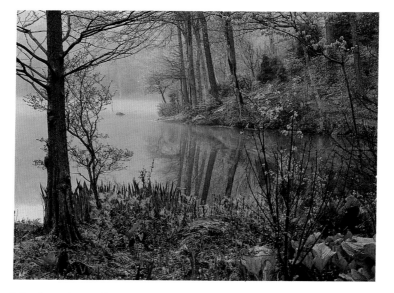

of the garden feel more intimate and personal.

In most gardens, clearings are carpets of grass, or wild grasses such as Little Bluestem and Sideoats Grama, which are easy to plant and maintain. For balance, they should be in keeping with the size of your property and the nature of your garden. In an informal garden, the clearings can be small spaces along the thread of the paths. In a formal garden, a clearing might be a central lawn, with straight edges and gates that lead to satellite lawns. On larger properties, clearings can be meadows or openings in the forest carpeted with shade-loving natives such as mayapple. A clearing can also be a patio or a sitting area, paved with gravel or stone or mulch, placed close to the house, or perhaps standing on its own. Besides serving as a resting place for the eye, a clearing will complement and balance the colors and textures of your garden's plantings.

Lesson 5: Layer Plantings

In a garden, plantings offer the best show when they are arranged in layers. Layers run in two directions. From paths or from clearings, the layers run horizontally, starting next to the path or clearing and moving away to the background. For convenience, most gardeners talk about plantings as divisible into "edges," "middles," and "backs." There are appropriate plants for all three areas. Along the edges, the best plants are low and fine-textured, with interesting colors. Here also is the place for small jewels that would be overlooked if they were farther away. Plants for edges include ground covers, such as

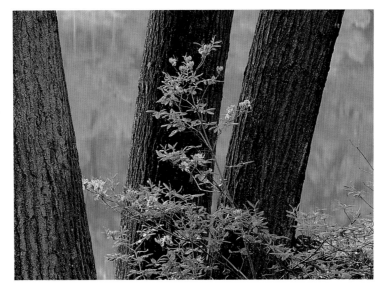

pachysandra, lirope, monkey grass, vinca, ivy, and lamb's ears. But many other plants are suitable for the edge as well, among them curly onion, bishop's weed, dwarf irises, creeping phlox, ice plant, and coreopsis. Behind the edge, the choices are almost unlimited. Here belong many of the flowering perennials, including lilies and day lilies, peonies, anemones, geraniums, and a host of other plants of middle height and size. At the back of the planting belong the tallest of perennials and shrubs.

Plantings also have vertical layers, which run from the ground covers to the top of your garden's tallest trees. The first layer consists of shade-loving foliage, plants and ground covers such as pachysandra, hosta, and ferns. Above these rise taller bulbs and flowering perennials. Next, the eye moves up to shade-tolerant shrubs—oak-leaf hydrangea and buckeye, for example—and small trees. The next layer is the taller under-story trees such as dogwoods and redbuds, over which stand the mature trees of the landscape.

Lesson 6: Planting in Groups

Planting in groups gives a garden dimension and drama. Among gardeners, the practice is usually called planting in drifts or masses. The idea is to group many specimens of the same plant together, and to orient the group so that it has an appealing shape and offers a suitable swath of color or texture.

Several principles underlie planting in groups. One is to put in an odd number of plants when you're planning to include relatively few. (Once the number of plants in a group exceeds seven or so, it

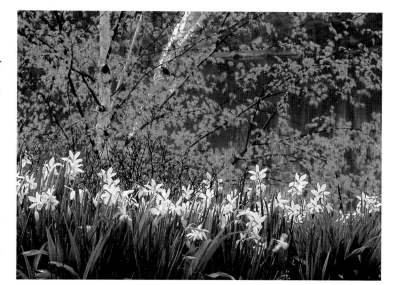

will not really matter if the number is odd or even.) A group with an odd number of plants is inherently more graceful than a group with an even number. To see this, try grouping similar household objects—say, glasses. Start with two: all you can do is place them side by side. Now try three—here there are many combinations. You can run them in single file, you can zigzag them, you can cluster them. Four becomes more awkward, since they can begin to resemble a square. Five again offers more possibilities.

Another principle of grouping is to make the plant arrangement long and thin for dramatic effect. Orient the length of the grouping so it faces your vantage point. In a perennial border, run the groupings roughly parallel, with one behind another and each grouping tailing off behind the start of the next. Seen from above, the effect is a bit like a half-shuffled deck of cards.

Lesson 7: Create Mystery and Surprise

Mysteries—hidden portions of the garden—are essential to personal gardens, the gardens you make in which to work, to stroll, to sit and enjoy. Imperceptibly, what lies ahead, hidden around the bend, draws you forward. Curiosity casts a spell. Estate gardens can dispense with mystery; they are meant for viewing through the windows of a manor house, or over terrace railings, and thus by design all the garden elements must be presented to the eye at once. But in personal gardens, mysteries create a great deal of pleasure. To enjoy the portions of the garden that are hidden from view, you have to ap-

proach them in person. What you pass along the way offers a familiar pleasure that is heightened by anticipation.

Mystery can be created in many ways. On a large hilly property like Cobamong, Nature itself does most of the work, but even in a flat yard you have several options. In the middle of the yard, plant a hedge that stops midway, then bend a path around it. If you have a detached garage adjacent to your house, and the yard extends behind the garage, plant a group of shrubs on the garage side, hiding a large portion of the back yard. Or, in the same position, erect a wing fence—a short section of fencing that stands alone and serves no purpose other than to conceal part of the view.

Even in a small yard, there are ways to create mystery. You simply have to match the size of the barrier to the size of the

yard. A hedge or a clump of five rhododendrons may suit a large yard, but a modest trellis or an arbor is perfect for a small yard. Or build a patio behind the house, screen it with hedges on three sides, then in one hedge install an arch with climbing roses—a gateway to secrets beyond.

Surprises are one of the rewards of garden mysteries. When a hidden portion of the garden comes into view, the surprise may be an unexpected vista, an alley through a grove of trees that looks across open fields, or a valley with distant hills on the far side. The surprise may be a vignette, a cul-de-sac enclosed by hedges that shelters a small bed of daylilies in bloom. Or the surprise may be a garden ornament, a terra-cotta birdbath, a statue, a gazing globe, a trellis covered with roses, a pedestal topped with an urn of cascading begonias. Or the surprise might be a

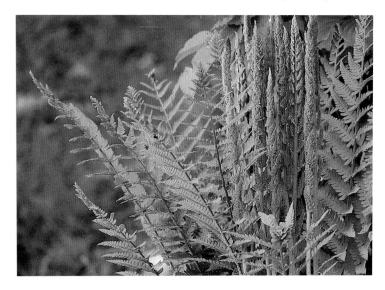

LESSON 7: A cinnamon fern, unexpectedly placed, offers an element of surprise.

refuge, a private spot to sit and enjoy the garden.

Garden surprises can also be secrets in plain view. To enjoy them, you have to slow down and look closely, your pace must come to a near halt at a spot where the path turns abruptly. There, plant swaths of daylilies or astilbes. Introduce sedums, and when they carpet the ground with a crowd of small, artichokelike rosettes, you can pause to enjoy the surprise of their neatness and profusion.

The paths of Cobamong offer more ideas for surprises, which you might adapt to your own garden. Rounding a turn on a path squeezed between the sprawling branches of an azalea on the right and a leaning beech trunk on the left, your next two paces bring you within earshot of falling water, and a few steps later, you find yourself beside a small pool that tumbles over the staircase of rocks and runs under a stone bridge just ahead. In another part of the garden, the path forks. When you take the branch that leads away from the lake, you discover a meadow of wildflowers in a clearing surrounded by azaleas and unbroken forest.

Lesson 8: Control Variety

To make a garden harmonious, you must control the variety of the plants. If you put in one of everything, in no order, without respect to compatible colors, shapes, and textures, the result will be a chaotic hodgepodge. Instead, limit the kinds of plants you grow. Pick them with care for their color, texture, size, silhouette, scent, and even for the feel of their bark. Then combine them with care.

The first consideration is controlling color. To avoid chromatic cacophony, group similar or harmonizing colors together: warm colors—reds, yellows, and pinks—in one grouping; and cool colors—bluish pink, blue, and white—together in another group. It is possible to assemble warm colors and cool colors in one garden, provided the groups stand apart, or are separated by a transitional area of intermediate colors or plants that provide a foil.

Leaf texture offers another opportunity to con-

trol variety. Among other things, texture is affected by the size of a leaf, by its smoothness or roughness, by the presence of toothed edges, and by how closely it grows to neighboring leaves. A plant such as rhubarb or gunnera, with leaves as big as dinner plates and teeth half an inch apart, is said to be "coarse-textured," while a plant like achillea, with its long, ferny leaves, is called "fine-textured." As a rule, strive for a balance between coarse and fine textures in the garden. Reserve coarse-textured plants for the background or for prominent positions where they catch the eye and serve as accents or specimens, and use fine-textured plants as foils, or for the front of a planting where their detail can be seen and appreciated.

In the garden, you should also control "growth habits"—a plant's characteristic silhouette and distribution of stems, branches, twigs, and leaves. Peonies, for example, have rounded habits, while pfitzer junipers have spreading habits. A ground cover like lysamachia has a trailing or prostrate habit. Lilies and fountain grasses have upright habits. Look for a balance among the habits of plants in the garden. Avoid excessive repetition of any habit. A common mistake—too many plants with rounded habits—can make a garden look monotonous.

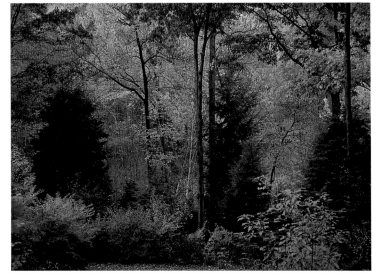

While the best way to control variety is to limit the kinds of plants you grow, you should also think about grouping together plants of like color, texture, or habit, just as you group plants of the same kind in drifts or masses. At the front of a planting, for example, you might mix two ground covers of similar habit, plants that stand no more than six inches high

LESSON 8: When planning a garden, consider variety in color, texture and contrast. Limiting the number of plants can also be important.

and have leaves of much the same size and texture, such as ajuga and vinca. Grouping similar plants creates the opportunity to make use of accents and specimens to greater effect, bringing attention to their special qualities. For example, a backdrop of evergreen shrubs, with small, simple, glossy leaves, can set off a clump of miscanthus, a grass with upright, arching blades.

Lesson 9: Provide for Seasonal Interest

In the garden, the right plants can guarantee four seasons of interest. Before you choose a plant, consider how it looks from spring through summer and fall, and on into winter. When does it bloom, and for how long? When it is not in flower, what does it contribute to the garden? In fall, does it drop its leaves, and if so does its silhouette provide interest in the winter?

Evergreens are the foundation of the garden, providing interest all year round. There are two groups: broad-leaved evergreens—such as rhododendrons, mountain laurels, leucothoes—and needle-leafed evergreens, which include most of the conifers—firs, spruces, hemlocks, pines, arborvitae, cypresses, false cypresses, and junipers. For variety and contrast, include both groups in your garden.

Also, choose different colors among the needle-leaf evergreens. While most are similar shades of green, there are many selections that offer unusual colors—pale green, yellow-green, gold-yellow, blue—and variegations that combine green and yellow, or green and white. In the garden, a blue conifer will make a useful transition between hot and cool colors and can also provide a foil for vivid colors in front of it. A conifer with yellow or gold foliage can brighten a slightly shady corner of the garden.

You can hasten early spring in the garden with a group of plants that bloom before all others. Witch hazel, for example, provides a misty show of yellow or red flowers on warm days in late winter, when the rest of the garden is brown or bare. Hellebore, a low-flowering perennial, starts blooming in late win-

ter and persists even when covered by snow. The low, nodding white flowers and straplike leaves of snowdrops also emerge in late winter, before any spring bulbs. They are followed by a succession of spring ephemerals, plants that in their native forests emerge and flower before the leaves of the trees close off the sun—for example, Virginia bluebells, with their tobaccolike leaves and clusters of drooping, pale-blue flowers. Dozens of these spring ephemerals usher in standard flowering bulbs, such as daffodils and crocuses.

For fall, consider the many plants that offer vivid leaf color. Blueberries turn scarlet red. Japanese maples turn amber, yellow, and red. Dawn redwood turns brown-gold. Dogwoods turn the color of old gold. Enkianthus, also called red vein, turns a flaming crimson in the fall. And the ornamental grasses, with their plumes of seed stalks, turn the color of straw and honey in fall, and then persist into winter, offering the eye relief from the browns of fallen leaves and the grays of twigs and bark.

Lesson 10: Focus on Change

Gardening is a pleasure in itself, not just a means to an end. As a garden grows and changes, so does the gardener. Some plants outstay their welcome, grow too large, prove to need too much coddling. Some look ungainly with age. Often the gardener realizes that a plant is growing in the wrong spot, among the wrong companions, and would look far better in another place. And new plants clamor for attention. The gardener ends an infatuation with daylilies and falls in love with native azaleas. And so plants are lift-

120

ed and moved, sometimes discarded, and in their place new plants take their turn.

Gardening is an art of living. Like eating well and cultivating friendships, it offers an unending journey. The lilac that you plant today in three years grows to shoulder-height, hiding your prize bed of irises; and you realize, happily, that you were never really content with the irises in that spot. When you have to move them, you discover that you would much rather have them at the start of the path, where you can

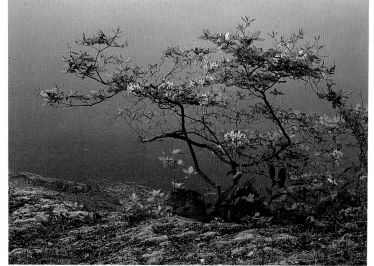

pass close by every day and enjoy them near at hand. The daffodils that once were just a spot of color in the landscape have now multiplied so freely that they form a wide-ranging bed, and when their grassy foliage yellows and withers in late spring, the effect is unsightly. When you start a ground cover amid the daffodils, they can emerge through it in the spring, and then decline back into it, out of sight. The garden changes every year, and you must learn to see it continuously anew.

The key to garden design lies in constantly asking yourself what you like. Do you like the grass path that leads from your patio to the perennial border alongside your house? Should the path have a different curve? Should it change direction before it reaches its destination? Should the edge be cut with a spade, or should it be marked with a row of bricks, or defined with a step or a set of steps to make the path more inviting? Learning to ask yourself what you like is one of the great pleasures of gardening; it opens up a future without end, of discovery and change.

When you ask yourself what pleases you in the

LESSON 10: Creatively moving a plant to a new spot can stimulate the gardener to make even more changes—a never-ending cycle.

garden, consider three main elements—the plants, the structures, and the layout. Are you happy with the color, texture, and form of a plant? Are you satisfied with the way it combines with its neighbors? Would another plant give more pleasure in the same place? Would new surrounding plants make better companions?

The structures in your garden deserve constant consideration. Have you chosen the right material for your paths? Should you transform the gentle slope behind your house into two terraces with a retaining wall? Should the bench under the apple tree move to the back of the garden, to become a focal point for the eye and the destination for the path? At the start of the path from the garage to the house, would a gate add a welcome ceremonial touch? Should the patio in back of the house be a rectangle or a curving shape?

Finally, consider garden layout. Does it take advantage of desirable views? Does it screen unwelcome sights? Does it reward you when you look out from the windows of the most frequently used rooms in the house—the kitchen, the dining room, the living room? Does it have mysteries? Does it offer a refuge and an overlook? Do the plantings have harmonious colors, drama, and four-season interest?

When you ask yourself what pleases you, look beyond your own property lines for answers. Visit your gardening friends; study their gardens; absorb their lessons. Look for inspiration at public botanical gardens and arboretums. They offer a wealth of ornamental plants grown beautifully and often married in winning combinations. Include nurseries in your quest; a good local nursery is an encyclopedia of plants that will do well in your area. As you walk the aisles past rows of containers, perennials, shrubs, and trees, exercise your imagination. Pause before the plants that catch your eye, and ponder where in your garden they might look best.

Finally, study and enjoy gardening books. Visiting Cobamong through photographs is the next best thing to walking the Cobamong paths. In the pages of gardening books, you can find incomparable treasures.

TREES (*with mature height*)

AMERICAN BEECH 80'–90'
Fagus grandifolia

AMERICAN ELM(S) 75'–90'
Ulmus americana & varieties

AMERICAN HOPHORNBEAM
30'–35' *Ostrya virginiana*

AMERICAN HORNBEAM 30'–35'
Carpinus caroliniana

AMERICAN WHITE ASH(ES)
60'–70' *Fraxinus americana
& varieties*

AMUR MAPLE 20'–25'
Acer ginnala

BALD CYPRESS 60'–75'
Taxodium distichum

BLUE CYPRESS 15'–20'
Chamaecyparis lanisoniana

CANADIAN HEMLOCK(S) 75'–90'
Tsuga canadensis & varieties

CAROLINA SILVERBELL 20'–30'
Halesia carolina

CHINESE FRINGETREE 20'–25'
Chionanthus retusus

COLORADO BLUE SPRUCE
60'–70' *Picea pungens glauca*

CRABAPPLE(S) 8'–20'
Malus & varieties

DAWN REDWOOD 50'–60'
Metasequoia glyptostroboides

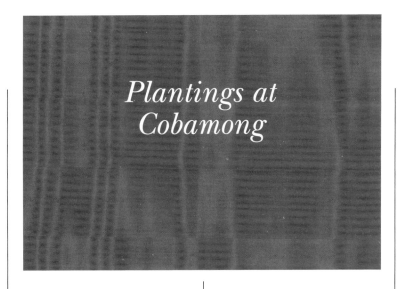

*Plantings at
Cobamong*

DOUGLAS FIR 70'–80'
Pseudotsuga taxifolia (douglasi)

DOVE TREE 20'–30'
Davidia involucrata

DOWNY SHADBLOW(S) 25'–35'
*Amelanchier canadensis
& varieties*

DWARF HINOKI CYPRESS 5'–6'
Chamaecyparis gracilis nana

FERNLEAF BEECH 40'–50'
Fagus sylvatica asplenifolia

FLOWERING CHERRY(S) 12'–30'
Prunus & varieties

FLOWERING PEAR(S) 25'–35'
*Pyrus calleryana
& varieties*

FRANKLINIA 15'–20'
Franklinia alatamaha

GINKGO(S) 60'–70'
Ginkgo biloba & varieties

GOLDEN BAMBOO 15'–20'
Phyllostachys aurea

GOLDEN LARCH 30'–40'
Pseudolaria kaempferi

HEDGE MAPLE 20'–25'
Acer campestre

JACQUEMONTI BIRCH(ES)
30'–40' *Betula alba
& varieties*

JAPANESE CORNELL DOGWOOD
20'–30' *Cornus officinialsis*

JAPANESE LARCH 50'–60'
Larix Kaempferi (leptolepis)

JAPANESE MAPLE(S) 3'–30'
*Acer palmatum
& varieties*

JAPANESE SNOWBELL 12'–15'
Styrax japonica

JAPANESE TREE LILAC 25'–30'
Syringa amurensis japonica

KATSURA-TREE 40'–50'
Cercidiphyllum japonicum

KOREAN MOUNTAIN ASH
30'–40' *Sorbus alnifolia*

KOREAN STEWART 30'–40'
Stewartia koreana

KOUSA DOGWOOD 16'–18'
Cornus Kousa

LACE-BARK PINE 50'–60'
Pinus bungeana

MAGNOLIA(S) 12'–20'
Magnolia & varieties

MUGHO PINE(S) 3'–4'
*Pinus montana mughus
& varieties*

NORTHERN RED OAK 75'–95'
Quercus borealis (rubra)

NORWAY SPRUCE 80'–100'
Picea excelsa (abies)

PAPER BIRCH OR
CANOE BIRCH 30'–40'
Betula papyrifera

PAPERBACK MAPLE 20'–25'
Acer griseum

PERSIAN PARROTIA 30'–40'
Parrotia persica

PIN OAK 75'–100'
Quercus palustris

RED OR SCARLET MAPLE(S)
50'–75' *Acer rubrum
& varieties*

COBAMONG LAKE

PATHWAY

ROCK OUTCROP

HOUSE

LAWN

0 50 100

N

Site plan of Cobamong, including lake, house and garden.
(Drawing by Ben Begley)

REDBUD(S) 15'–20'
Cercis canadensis
& varieties
RIVER BIRCH(ES) 40'–50'
Betula nigra & varieties
RUBY HORSECHESTNUT 50'–60'
Aesculus carnea briotti
SASSAFRAS 40'–50'
Sassafras albidum
SCARLET OAK 75'–90'
Quercus coccinea
SERBIAN SPRUCE 60'–80'
Picea omorika
SIBERIAN DOGWOOD 8'–10'
Cornus alba sibirica
SOURGUM OR TUPELO 40'–60'
Nyssa sylvatica
SOURWOOD 25'–30'
Oxydendrum arboreum
STELLAR SERIES DOGWOOD
18'–20' *Cornus Rutgers Aurora*
SUGAR MAPLE(S) 50'–75'
Acer saccharum
& varieties
SWEETGUM 50'–60'
Liquidambar styraciflua
SWISS STONE PINE 25'–30'
Pinus cembra
THREAD LEAF JAPANESE MAPLE(S)
3'–30' *Acer palmatum*
dissectum & varieties

TRIDENT MAPLE 15'–20'
Acer buergerianum
TULIPTREE 60'–80'
Liriodendron tulipifera
WHITE FIR 20'–25'
Abies concolor
WHITE FLOWERING DOGWOOD(S)
15'–25' *Cornus florida*
& varieties
WHITE FRINGETREE 15'–18'
Chionanthus virginicus
WHITE OAK 80'–90'
Quercus alba
WINTERBERRY(S) 6'–8'
Ilex verticillata
YELLOWWOOD 30'–40'
Cladrastis lutea
ZELKOVA(S) 60'–70'
Zelkova serrata(s)

SHRUBS

AMERICAN REDBUD, JUDAS-TREE
12'–15' *Cercis canadensis*
ARNOLD WITCHHAZEL(S) 10'–12'
Hamamelis & varieties
BLUE CYPRESS 18'–20'
Chamaecyparis lanisoniana
CHINESE REDBUD 8'–10'
Cercis chinensis
CORKSCREW HAZELNUT 6'–8'
Corylus avellana contorta

COTONEASTER(S) 6"–2'
Cotoneaster varieties
EXBURY AZALEA 6'–8'
Azalea exbury hybrids
FIRETHORN(S) 2'–5'
Pyracantha coccinea
FLAME AZALEA 6'–8'
Azalea calendulacea carat
FLOWERING QUINCE 4'–5'
Cydonia japonica
(chaenome les speciosa)
FORSYTHIA(S) 2'–8'
Forsythia & varieties
FOTHERGILLA(S) 4'–10'
Fothergilla & varieties
FRAGRANT SUMAC 4'–5'
Rhus copallina
HYBRID AZALEA(S) 1'–5'
Azalea hybrids
& varieties
HYDRANGEA(S) 3'–6'
Hydrangea & varieties
JAPANESE ANDROMEDA(S) 5'–6'
Pieris japonica
& varieties
JAPANESE SNOWBELL 12'–15'
Styrax japonica
JUNIPER(S) 1'–3'
Juniperus & varieties
KOREAN AZALEA 3'–4'
Azalea poukhanensis

LEUCOTHOE(S) 2'–4'
Leucothoe axillaris & varieties
LILAC(S) 5'–12'
Syringa & varieties
MUGHO PINE 3'–4'
Pinus montana mughus
PINXTBERBLOOM AZALEA 4'–5'
Azalea nudiflora
RED CHOKEBERRY 6'–8'
Aronia arbutifolia
brilliantissima
REDVEIN ENKIANTHUS 8'–10'
Enkianthus campanulatus
RHODODENDRON(S) 2'–12'
Rhododendron & varieties
SPICEBUSH 6'–8'
Lindera benzoin
SUMMERSWEET 4'–5'
Clethra alnifolia
SWAMP AZALEA 6'–8'
Azalea viscosa
TRIDENT MAPLE 15'–20'
Acer buergerianum
VIBURNUM(S) 3'–12'
Viburnum varieites
WEIGELA(S) 5'–6'
Weigela varieties
WINGED EUONYMUS 6'–10'
Euonymus alatus
WINTERBERRY 6'–8'
Ilex verticillata

Acknowledgments

Henry Malewitz is perhaps the most important person in helping create this garden. He is a gardener extraordinaire. Cobamong looks happy when he is here.

A very important person in our building project was my dear friend Jens Quistgaard, the Danish designer whom I met in 1953 when I started Dansk Designs. Jens, a designer and craftsman without equal, and I were fascinated by heavy timber construction and its aesthetic in Norway and Japan. When we first encountered giant Douglas Firs in the Northwestern U.S.A., we conceived of constructing the Cobamong house of heavy fir timbers. This unique house is his creation.

Ernst Haas, now deceased, my friend and finest teacher, led me to 35mm. He encouraged me to take photographs over and over again, to follow my own instincts.

John Szarkowski, who guided the department of photography at the Museum of Modern Art in New York for almost three decades, offered me a candid critique of my portfolio before I began my garden project. His suggestion that I make ten thousand photographs a year for five years, and edit them down to one-hundred fifty, led directly to this book.

Three people were inordinately encouraging throughout this process. Angeles Rodrigues, our housekeeper, became an avid learner with me; Russ Dusek, an accomplished designer, constantly criticized and encouraged me; our old friend Vera Freeman's enthusiasm was expressed with the phrase "I like that photo — a lot!"

Photographer Linda Waidhofer — the most demanding photo critic I've ever met — and her husband Litto Tejada-Slores were the first people to suggest the work be published. Cornell Capa, founder of the International Center of Photography, viewed my garden photos and exclaimed, "Bravo!" At the Aperture Foundation, I met Michael Hoffman, executive director, whose courage has guided Aperture's role in making powerful statements about social and environmental issues. Rebecca Busselle, who became my editor, is a delightful and stimulating person; together we have had fun doing this project.

I turned to the editor of Fine Gardening, Mark Kane, to create an essay to accompany the photographs. Mark came to the garden only twice: together we walked and talked, and although he never made a note, he saw and remembered everything. He developed the essay and the title, and both are wonderful.

Last fall Peter Galassi, who succeeded John Szarkowski at the Museum of Modern Art, kindly reviewed my editing.

But nobody has been as energizing and nurturing as my old friend Lou Dorfsman, the internationally recognized graphic designer, who guided the creative efforts of CBS and countless other activities. He has guided this endeavor as well. It is the work of Peter Bradford and Danielle Whiteson who, in designing this volume, made The Beckoning Path so much more inviting.

—TED NIERENBERG, Cobamong, Armonk, NY

Library of Congress catalog card number: 93-71119
ISBN:0-89381-544-6

Book and jacket design by
Peter Bradford and Danielle Whiteson.

The staff at Aperture for
The Beckoning Path: Lessons of a Lifelong Garden:
Michael E. Hoffman, Executive Director
Rebecca Busselle, Editor
Michael Sand, Managing Editor
Sandy Greve, Production Associate
Stevan Baron, Production Director
Jenny Isaacs, Editorial Work-Scholar

Color separations by Sfera, Milan, Italy.
Printed and bound in Italy by
Sfera/Officine Grafiche Garzanti Editore S.p.A.

Aperture publishes a periodical, books, and portfolios
of fine photography to communicate with
serious photographers and creative people everywhere.
A complete catalog is available upon request.
The address is: Aperture
20 East 23rd Street, New York, New York 10010.

First edition 10 9 8 7 6 5 4 3 2 1